NASHVILLE
GHOSTS AND LEGENDS

NASHVILLE
GHOSTS AND LEGENDS

KEN TRAYLOR
AND DELAS M. HOUSE JR.

HAUNTED
America

Published by Haunted America
A Division of The History Press
Charleston, SC 29403
www.historypress.net

Cover Image: Union station.
All photos courtesy of the author.

First published 2007

Manufactured in the United Kingdom

ISBN 978.1.59629.324.3

Library of Congress Cataloging-in-Publication Data

Traylor, Ken, 1947-
Nashville ghosts and legends / Ken Traylor and Delas M. House, Jr.
p. cm.
ISBN 978-1-59629-324-3 (alk. paper)
1. Ghosts--Tennessee--Nashville. 2. Haunted places--Tennessee--Nashville. 3.
Legends--Tennessee--Nashville. I. House, Delas M. II. Title.
BF1472.U6T75 2007
133.109768'55--dc22
 2007026827

We dedicate this book to the following people:

To our son Mat, one great kid.

To Kristopher, another great kid.

To Dave and Annie, my best friends and people who know how to be true friends.

To my mom's memory—she was my guiding light and a wonderful mother.

To my brothers and sisters-in-law: Tim and Mimi, Dan and Cynthia and Gary and Colette. Thanks for your love and support.

Royce, thanks for being a great friend to the both of us. We love you very much.

To my mom Carol, whom I love very much and in memory of my dad, Delas, I love and miss you.

And to my little sister, Tammy, thanks for all you have done for me. I love you.

And to my sister, Debbie, and brother, Billy, thanks for your support. I love you both.

And to my daughters, Montanna and Micayla, I love and miss you more than life itself.

And to Seth, how proud I am of you. What a great young man you have become.

And to Uncle Jack and Aunt Suzanne and Aunt Marie and Uncle Bob, thanks for your love and support.

To Mark, Cyndi, Pam and Cherish, thanks for all your love and support. I love you all very much,

Contents

Acknowledgements

We would like to thank the following people for their contributions:

Suzette and Alley Boutilier
Renaye Owens
Heather Gray
Beth and Jim Strickland
Melissa and Alex Strickland
Rachel, Robbie and Gwen Falbo
Candice Pressley
Irene and Doug Catania
Shane and Anna Dasher
Shelly and Kevin Peterson
Jeff, Carlos, Selina and Jacob
Merry, Dell and Charles
Amber and Denver
Dustin and Jacob
Amanda and Sabrina
Bob and John
Johnny and Jill
Nan and Fred Herdrich

Introduction

Welcome to the fascinating world of the spirit realm and the legends that abound within that domain. Are you a believer, disbeliever or, like most, what I call a "fence-sitter"? Join me on this wonderful and sometimes scary journey and decide for yourself where you reside. Keep your mind open as we venture from one legend to the next, ever-watchful for the shadowy details that might sway you toward a new set of convictions.

Have you ever felt a cold chill course through your body even when it is warm or hot outside? Have you ever turned around quickly, certain of a presence behind you, only to find that there is no one there? Have you ever heard a voice speaking to you even though you are the only one around? We all have had experiences like these throughout our lives. Some of us disregard them completely, some of us speculate—if only momentarily— and some of us, like myself, know what these experiences indicate. I have made it clear exactly where I stand on this subject (as if any of you reading this book should have had a doubt). Although I know what the truth is, as I perceive it, I will let the legends speak for themselves.

Nashville has a long and unique history. Located on the Cumberland River, it was an ideal spot for the local Native Americans to establish their camps and trading outpost. The river provided ample fishing, and area hunting was plentiful. In 1775 the United States and the Cherokee Nation signed a treaty called the Transylvania Treaty, which in essence sold a large chunk of the Cherokee territory to the United States. One of the leading chiefs of the Cherokee, Dragging Canoe, was very much against the sale of their land. He declared that it was bloody land and predicted that it would be extremely difficult for the white man to settle. On Christmas Day 1779 the first white settlers arrived and established camp, which soon turned into a fort. They named the area Nashborough.

Little did anyone at the time know just how true Dragging Canoe's prediction would prove to be. He himself led many of the war parties against the white settlers. For the next fourteen years the area was home to a great deal of violence and bloodshed.

Once the Native Americans had been forced out of their homeland, Nashborough began to flourish due to the river access for trade in the area. In 1806 Nashville was incorporated. It was just a short five years later that Nashville became home to its first music star. In 1811 a young man by the name of Davy Crockett came to town to stay. He was a well-known buck dancer and fiddle player. In 1821 Crockett was elected to the Tennessee legislature and served three two-year terms. From 1827 to 1833 he served in the Congress of the United States. He was narrowly defeated in a bid for a fourth term.

Disgusted with politics by that time, Crockett bid farewell to Tennessee and set out for Texas in the fall of 1835. He thoroughly enjoyed his new home, writing on January 9, 1836, to his daughter in Tennessee: "I would rather be in my present situation than to be elected to a seat in Congress for life."

Unfortunately, less than a month later, along with other fellow Tennesseans, Davy met his final fate defending the Alamo.

Nashville is famous for being the sight of what is considered by most to be the second most important battle of the Civil War, the Battle of Nashville. It was a decisive victory for the North, which had been encamped in Nashville since near the beginning of the war.

Nashville is also known for a number of "firsts," many of them music related. It was the home of the first river showboat, *Noah's Ark*. Though not the ark of biblical fame, I'm sure you can guess the name of the man who owned it.

Another first for Nashville came in the music publishing business. In 1924 a book of hymns called *Western Harmony* was published.

Nashville was home to the first recording studio. It was called Castle Studio and was directly associated with the Grand Ole Opry.

In 1950 a local radio deejay by the name of David Cobb ad-libbed the phrase "Music City, USA" and the rest is history. Today, Nashville is not only the home of country music, but it is also home to many other genres of music.

Because of its rich Native American history and its role in the Civil War where tens of thousands lost their lives, Nashville has the distinction of being one of the most haunted cities in the U.S. In my vast experience of conducting year-round ghost tours in a number of cities around the country, I have found Nashville to be the most active of any in which we operate in terms of paranormal activity.

Introduction

Once again, I remind you that I am not attempting to change your beliefs—whatever they might be—but my goal is to guide you into the paranormal realm of this great city and to explore and divulge to you its dark and mysterious ghosts and legends.

So, if you dare, follow me for a unique and unusual adventure into the spirit realm of this fascinating and otherworldly city.

The Spirits of the State Capitol

The first stop on our journey is a visit to the state capitol to learn of the ongoing legends that have surrounded it almost since its completion.

The capitol was built between 1849 and 1859—a long project indeed! The architect of the building was William Strickland. He was hired by the State Capitol Commission to come to Nashville from Philadelphia (where he was much lauded as the city's top architect)—an honor never before or since bestowed upon another. Strickland anticipated that the capitol project would consume two and a half to three years of his time, after which he planned to return to Philadelphia. Much to his chagrin the project dragged on for over nine and a half years. He actually never lived to see its completion, passing away in 1854. In honor of his dedication to the project the Capitol Commission members decided to inter Strickland's body inside the building, where it remains to this day.

The commission also hired a construction superintendent to oversee the actual day-to-day operation. His name was Samuel Morgan. To say that Mr. Morgan and Mr. Strickland were compatible would be a gross misrepresentation. They were about as like-minded as a shark and a school of fish. The two harbored an instant hatred for each other. It is widely believed that Morgan purposefully delayed the project at every step to spite Strickland, blaming the delays on Strickland's constant design changes. Of course, Strickland, conversely, blamed Morgan for all of the delays.

To the surprise of many locals, the Capitol Commission decided to bestow the same honor upon Stanley Morgan as they had William Strickland. When Morgan passed away his body was entombed in the capitol building, on the opposite side of Strickland's. It is almost as if the commission members were so fed up with Morgan and Strickland's constant bickering and fighting that they determined to have the last laugh by deliberately placing them close

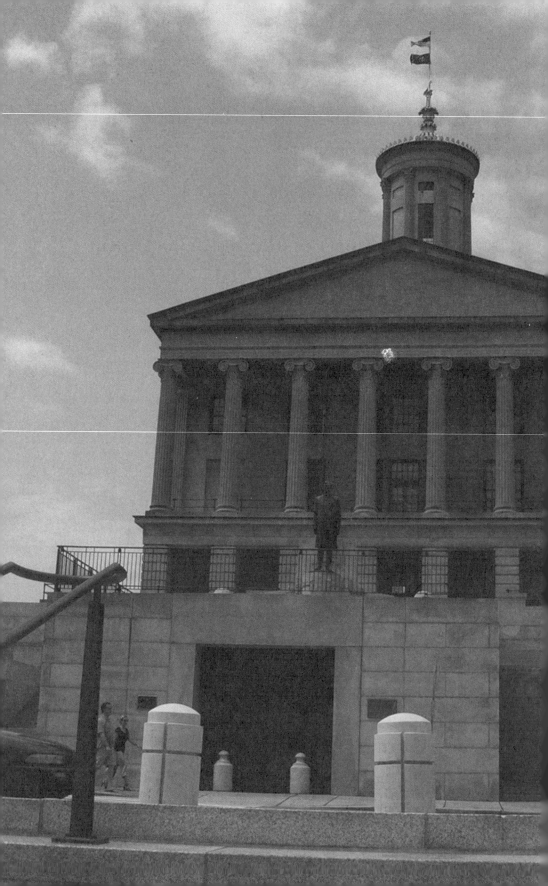

State Capitol building.

together forever. Little did they realize the consequences of their actions: to this day the bickering and fighting between the two men continue.

The capitol security staff are the ones who report most of the paranormal activity. Often, late at night, the guards will hear two men yelling at each other. When they go to investigate the disturbance, approaching the area from where the noise originates, all they find are empty halls and sudden, eerie quiet. They return to their posts and hear nothing unusual for the rest of the evening.

On one particular occasion a new security guard was put on the hourly security check rounds of the interior of the building, clocking in at a number of stations to indicate that all was well. Upon arriving at the far corner of the building, he suddenly was startled by the screaming voices of two men. Looking around frantically to ascertain the origin of this disturbance, he was drawn closer and closer to a door that led to the outside of the capitol. It was against policy for anyone to open any door after hours without another guard present, but the screaming and yelling became even more intense and the guard feared that there would be violence of a physical nature if he did not at least attempt to intercede. Cautiously, the man slowly pushed open the door, wishing that this was happening to one of the more experienced guards, for surely no good could come of this situation.

Suddenly, a piercing scream so loud and close to him sent him toppling to the ground. He was convinced that he was about to be attacked and that some painful and terrible event was about to befall him. As quickly as the scream resounded it was just as quickly stifled. He felt the air turn cold all around him even though it was midsummer and, despite the lateness of the hour, it remained quite hot and humid from the unrelenting beating of the sun during the daylight hours.

Pulling himself up to a sitting position, the guard leaned against the exterior wall completely drenched in perspiration. His eyes darted back and forth like those of a threatened and cornered animal. He was barely able to control his shaking hands, and he searched his shirt pocket for his cigarettes. Lighting up and inhaling deeply, he tried to make sense of what had just occurred. Minutes later he was discovered in his repose by another guard who had been sent to find out what had happened to him. Unwilling or unable to explain his actions, he simply got up, brushed past the guard and made straight for his locker. Hastily pulling his possessions out and stuffing them into a backpack, he hurried out the front doors, down the stairs that led to the street and was never heard from again.

The capitol was also the site of a very bloody and ferocious battle during the Civil War. The North occupied Nashville shortly after the outbreak of the war. The second most important battle of the war, the Battle of

Nashville, was fought in what is now the downtown area of Nashville. Many thousands of soldiers from both sides died in combat and a good number of those deaths occurred at the capitol. The capitol had been heavily fortified, and a large contingent of Union soldiers had been assigned duty there. To this day the spirits of many of those men remain in and around the capitol grounds, unable to continue their journey to the "other side" due to the fact that they do not realize they are dead, or they feel there is some uncompleted task that they must finish before taking their final rest.

On a local ghost tour by the name of Haunted Ghost Tours there have been thousands of guests who have taken pictures of paranormal activity at the capitol. On some nights it looks like a snowstorm of spirit orbs on the screens of the digital cameras brought by the guests. Many guests who are sensitive to the spirit realm have reported feeling cold spots around them on warm or hot nights, cold breezes blowing from nowhere, or simply sensing many spirits present in the area.

One particular evening, a guide reported that a guest abruptly started to cry uncontrollably. When quizzed as to what was wrong the guest stated that someone had just whispered a name in her ear, but when she spun around to see who it was no one was near her. She said that the person had whispered a nickname that her father had called her since she was a little girl, and she had been told that this nickname had been passed down by several generations of his family. One of those family members had been a soldier in the Confederate army and had been killed at the Battle of Nashville. She truly believed that since no one on the tour could have possibly known the nickname she had been called by the mysterious voice that night that she had been visited by her great-great-uncle who died on those grounds. She excused herself and left the group, saying she would be too upset to continue on and wanted to be alone with her thoughts.

When in downtown Nashville at night I recommend that you visit the state capitol with your digital camera and spend some quality time with the spirits that still reside there from the area's historical past. Listen intently while you are there for any unusual voices or sounds. If you do hear something, rest assured that it is only the eternal bickering of Morgan and Strickland or the Civil War soldiers trying to tell you their stories.

Have a great visit!

The Holy Spirits of St. Mary's Church of the Seven Sorrows

Our next destination is the beautiful old Catholic Church known as St. Mary's Church of the Seven Sorrows. Built between 1844 and 1847, William Strickland is the credited architect, but due to the time frame most people believe that another architect was actually the designer.

St. Mary's is the oldest standing church in Nashville. The first appointed bishop for the diocese, Richard Miles, supervised its construction. When Bishop Miles passed away he was entombed in the church. His remains were moved some years ago due to a construction project but still remain within the confines of the building.

The church was also used as an army hospital during the Civil War, and more than three hundred men died on the floors of the building. As you can imagine, many of those tortured souls still remain in the church to this day, wandering its grounds along with Bishop Miles. It has been reported by many that the ghostly image of Bishop Miles can often be seen walking through his beloved church as though still supervising its construction.

If you ask the cleaning lady who worked at St. Mary's for years about her experiences with the bishop and some of the other poor souls trapped within the confines of the church, she will shyly look away, as though embarrassed by her knowledge of those events. For surely you would deem her crazy or mentally ill if she told you she has heard the undeniable moaning of men. She has always imagined that those moans come from the Civil War soldiers who were brought to the church to receive some type of crude medical care or to simply die on the floor, away from combat.

The first experience she had with the sounds occurred during a routine morning cleaning of the main chapel. She knew she was alone in the church as it was her practice to lock the doors so as not to be surprised or scared by some well-meaning parishioner stopping by to pray his rosaries. She was

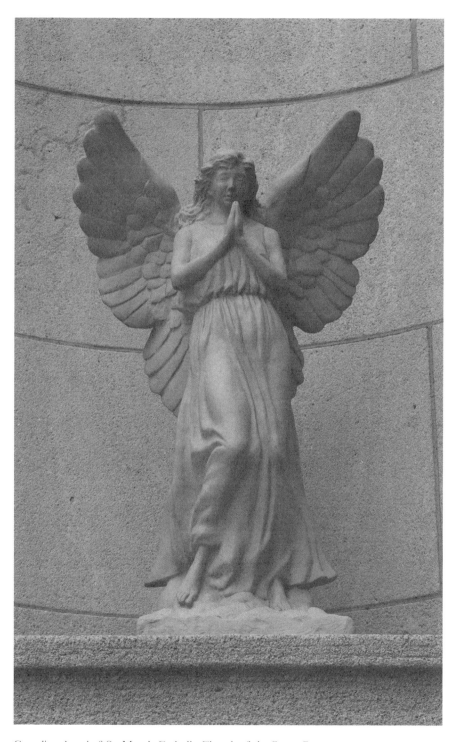

Guardian Angel of St. Mary's Catholic Church of the Seven Sorrows.

bent down on her knees scrubbing an area between the pews when suddenly, from no discernable location, came a series of moans. Startled, she rose quickly to her feet, fully expecting to see someone standing behind her. But no one was there, even though in her confusion she turned a complete circle several times. By this time, the moans had stopped, and she simply shrugged off the noise, attributing it to some kind of loud commotion coming from the street.

Returning to her knees, she again numbed her mind to the task at hand only to be startled once again by the same sounds. This time she knew, without doubt, that the moans were coming from inside the chapel—and they were close by. Frightened, she slowly raised her head to peer over the top of the pew in front of her. Becoming increasingly scared with each passing second, she began to worry that she might be in danger. Surely, these horrible noises were coming from someone in serious pain, but how to explain the magnitude and the fact that there wasn't another living soul present? She swore herself to secrecy, convinced that no one would believe her story and simply think her insane.

About two months later, she was once again cleaning the main chapel, now fairly comfortable with the moans that occurred on a regular basis, when she decided to take a break for lunch. Sitting down on one of the pews, she opened her brown bag and withdrew a sandwich. Before unwrapping it she went to the restroom to wash her hands. Returning to the pew she found that the wrapping was undone and a bite was missing from the sandwich. Who would have done such a thing? She knew the maintenance man was down in the basement, but he never came up to the chapel when she was cleaning. Obviously, on this particular day, he must have decided to play a practical joke on her and had taken a bite out of her lunch.

Locating him in his usual domain of the basement she confronted him about his prank. Looking totally bewildered, he denied any involvement. After more declarations of his innocence, he asked her if she had ever had any unusual or strange experiences while in the church.

A look of sudden suspicion crossed her face as she feared that she had been discovered acting strangely while hearing the moans. He quickly proceeded to explain to her that he had often had strange events occur to him while working in the basement. As he told her about hearing loud moaning, the cleaning lady reeled back, flopping unceremoniously into a chair. She felt a wave of relief and vindication rush over her.

The two spent the remaining balance—and then some—of the lunch period grilling each other about their personal experiences with the moans. Many questions arose with no definitive answers, but each had suspicions. They both had read up on the history of the cathedral and knew of the

soldiers that had been brought there to be treated for wounds or to die. They agreed that the moaning must come from those fallen soldiers.

Giddy at the fact that they were no longer alone in their experience, they soon began to relay other rumors they had heard from some of the parishioners about Bishop Miles's movements about the church property. One of the more persistent rumors came from one of the past priests who claimed he was awakened from a sound sleep by a loud knocking on the headboard of his bed. Fumbling for the light switch on his nightstand lamp he squinted as brightness flooded the room. As he focused on his surroundings, it became chillingly apparent that he was alone. He decided that a transfer would be the best course of action.

When visiting downtown Nashville, I encourage you to stop by and observe the beauty of St. Mary's. During your tour you may be fortunate enough to witness another strange event that occurs there on a regular basis. At night, when no one is in the church, the bell in the tower will ring out. There is no set pattern to the ringing, but many assume it is the bishop himself beckoning his flock to attend the next mass.

Is the hair on the back of your neck rising yet?

The Legend of the Southern Turf Building

There is an existing building in the downtown area located right in front of a now lively and fun area known as Printer's Alley. The building is called the Southern Turf Building, built in 1895 by a gentleman named Marcus Cartwright.

The Southen Turf Building housed one of the most elegant saloons of its day, decorated with only the very finest in building materials, chic paintings, bronze statues and stylish furniture. By day the area was highly respectable and conservative. By night it took on a whole different guise. Known in the twilight hours as the Men's Quarter, gambling, drinking and ladies of the evening were standard fare, and the only laws broken at the time were moral ones. No self-respecting lady would dare enter this area after dark if she could avoid it.

The glitz and glitter of the area faded with the advent of Prohibition. Throughout this period, a gentleman named Ice Johnson managed the building for the owner and resided on the third floor. When the saloon closed in 1916, Ice shot himself in the head and died instantly. He left a note saying that he preferred death to leaving his beloved building and job. Shortly after his demise, reports started circulating that a man could be seen standing in a window on the third floor, exactly where old Ice had lived for all those years. At first these reports where simply ignored or scoffed at by the general public, but investigations of the third floor revealed that no one had been there since the building was abandoned after the closing of the saloon. The rumors and reports continued for many years and pretty soon it was accepted that the man in the window was indeed the ghost of Ice Johnson. He obviously was intent on never leaving the building that he so loved.

But this is only the beginning of the legend. When the building finally was refurbished and started to be rented to lawyers and other business tenants

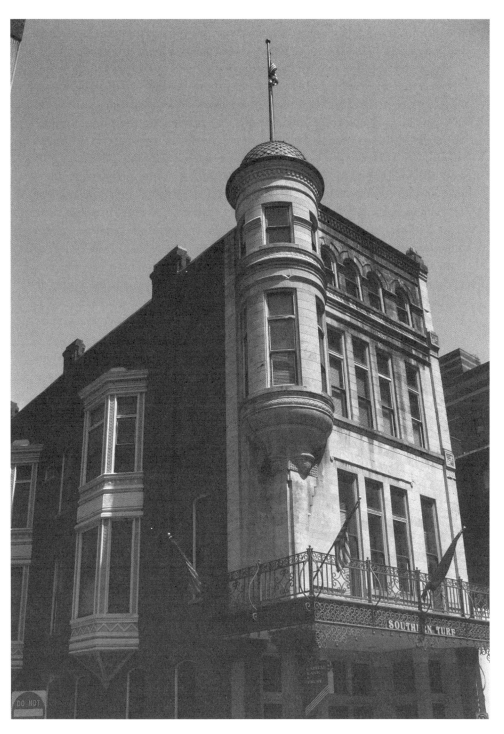

Southern Turf building.

there came about a whole new set of events and rumors that quickly turned into hard-held beliefs by those who witnessed the strange occurrences.

Apparently old Ice did not like new people moving into his building and decided that he would do his best to get them to leave. At first he would simply move items around on these newcomers' desks. This action prevailed for several years before he decided this was not having the desired effect. Ice decided that personal appearances might do the trick, so he set about making his presence known by appearing before different individuals all over the building. This proved more successful as some people quit their jobs and moved on. When he had scared off as many as he could the rest of the tenants simply accepted his ghostly presence and went on about their daily routines. Ice apparently became complacent about the tenants, and his appearances became less and less frequent over the next ten years or so.

In the last few decades Ice has taken a fondness to making his presence known to nighttime visitors to the area. He does so by appearing in one of the bay windows on the third floor where his old apartment was maintained. He is often reported as appearing very late at night and, once noticed by an onlooker, he begins to dart from one window to the next at a speed unattainable to any living human. Needless to say, this has made more than one observer of Ice Johnson leave the area at a rather rapid pace.

One of Ice's regular targets was a gentleman named David "Skull" Schulman. "Skull," as he preferred to be called, was a very long-term resident of the building, having located his famous Rainbow Room lounge in the basement with its entrance in what is now known as Printer's Alley. For many years, as "Skull" tabulated up the day's receipts and performed other various tasks connected with running the bar, he would hear old Ice roaming around the club. He often reported that Ice would move things around in his storeroom and liked to push bar stools and tables around the place as if trying to scare "Skull" off. "Skull" himself was known for being very eccentric in both his manner and wardrobe, so it seemed that Ice had really met his match. After a few years of making his presence known to "Skull," old Ice must have finally decided that "Skull" was even scarier than he, and he never bothered or visited the lounge again. There's more to the story of "Skull" Schulman, but we'll get to that in the next chapter.

When visiting Nashville I urge you to go to Fourth Avenue between Union Street and Commerce Street not only to visit Printer's Alley, but also to view the old Southern Turf Building and perhaps catch a glimpse of old Ice Johnson standing at his post in the third floor window.

The Murder of "Skull" Schulman

You were introduced to David "Skull" Schulman in our last legend, but now you will learn a great deal more about him. As I mentioned before, "Skull" was known not only for his famous nightclub where a number of stars were discovered, but also for his eccentricity. John Lennon, the famous Beatle and solo artist, one day sauntered into "Skull's" Rainbow Room, sat down at the bar and penned one of his more famous songs.

"Skull" earned his eccentric reputation for several reasons. He was an imposing figure, standing at six foot four inches tall and thin as a rail. To accentuate his height he dressed in quite bizarre clothing. At times he would wear suits made of multicolor patchwork material, and his normal attire was bib overalls. To add to this overall image he would at times wear a bright colored hat. Always at his side was his faithful companion, a white poodle, who was never well groomed and appeared to always need a bath. "Skull" would stroll down the alley all ablaze in his colorful attire, led along by his faithful dog as it strained on the leash as though attempting to make a mad get away. As eccentric as he might have been, "Skull" was also a well-loved member of the business community and had many loyal and devoted customers.

Around 4:30 p.m. on the afternoon of January 21, 1998, a taxicab driver dropped "Skull" at the Rainbow Room just before it opened for the evening. "Skull's" normal routine was to sit at the end of the bar reading the newspaper until it was time to open. "Skull" had kept up this routine for over fifty years.

At approximately 6:00 p.m., William Jones, a salesman who serviced the bars in Printer's Alley, made a routine stop at the Rainbow Room. When he walked in, Mr. Jones did not see "Skull" sitting in his usual spot, so he walked down to the other end of the bar where he found "Skull" lying on

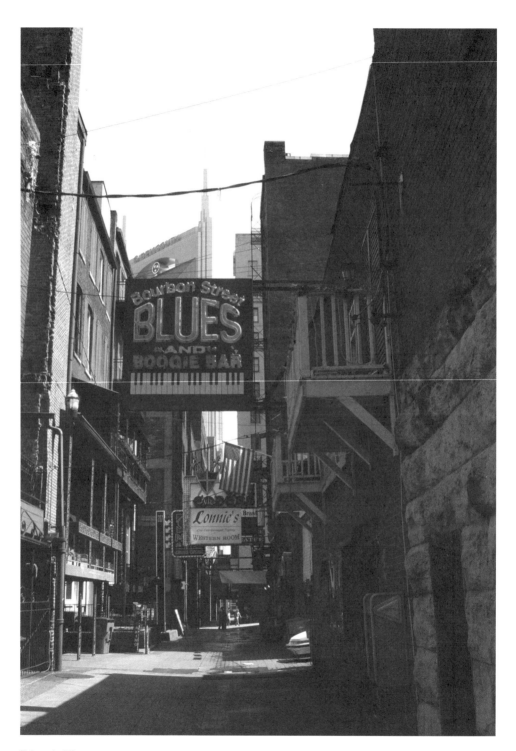

Printer's Alley.

the floor, clutching his hands to his throat. Mr. Jones ran out of the bar to find help. "Skull" was transported to the hospital where the next morning he died.

What happened to "Skull"? The assistant medical examiner who performed the autopsy testified that the cause of death was multiple incision wounds to the throat and a blunt force injury to the head.

There was very scant evidence as to whom the perpetrator or perpetrators were at the time of the crime. There was a good deal of investigation into the crime, and a few leads did start to develop. The story even appeared on the television program *America's Most Wanted* in order to generate new leads.

The perpetrator who was finally arrested and convicted of the crime was a man by the name of James Cavaye along with an accomplice, a man named Pence. The two of them, both homeless, had met across from the Rainbow Room in a parking garage and plotted the robbery of "Skull" and his bar. Mr. Pence had worked for "Skull" a few years earlier as a custodian. "Skull" had a reputation for helping out the homeless in the area, and it was generally known that "Skull" would carry the money he used to open the bar in his bib overalls.

In testimony at the trial, Mr. Pence admitted that he and Cavaye had planned to rob "Skull," but that things went awry when "Skull" refused to give up the money. Cavaye walked up behind "Skull" and placed a knife to his throat, once again demanding his money. Again, foolishly, "Skull" refused, and Cavaye cut his throat three times. They were somewhat superficial wounds and would not have killed "Skull" right away. Mr. Pence testified that at this point "Skull" started yelling out for help, and when he refused to keep quiet, Cavaye took a liquor bottle and smashed it against the left side of "Skull's" head, thus silencing him once and for all.

The coroner reported that the cause of death was a combination of both the cuts to the throat and the head wound. James Cavaye was sentenced to life for the murder with a consecutive sentence of twenty-four years for especially aggravated robbery. But this is not the end of the story.

Old "Skull" has decided not to leave for the "other side," at least as of the time of this writing. His presence is often felt up and down Printer's Alley both by employees working in the other bars and patrons who never had the privilege of knowing or seeing "Skull" during his life. One of the more common events reported is the sight of a man walking a small dog on a leash. He always appears to be walking away from the person who notices him. Most pay no extraordinary attention to this scene until, all of a sudden, the man and his dog simply dissipate before their very eyes. It has been said that several of those who spotted "Skull" rapidly left the alley, swearing never to have another drop to drink as long as they lived.

The Rainbow Room closed after "Skull's" death and remains closed to this day. There is an alcove in the front of the building that leads to the front door of the club. It is very dark, and it is here that a local ghost tour by the name of Haunted Ghost Tours of Nashville takes their guests to share both the legend and the history of "Skull" and his bar. It is also the sight of where many a fantastic picture has been taken showing all types of paranormal activity. One of the more common pictures taken is a face that appears in the alcove. One can only assume that it is "Skull."

One report documents "Skull" coming around the corner with his dog in tow, walking into the alcove and right through the door of the bar. This was observed by a group of tourists as they were leaving the alley. They hastily reported what they had just seen to the doorman who was sitting in his usual spot on a stool outside of the bar next-door. His comment was that it happens fairly regularly and that he had also seen "Skull" and his dog walk into the bar.

The next time you are visiting downtown Nashville I recommend taking the Haunted Ghost Tour of Nashville (www.hauntedghosttours.com). You will stop by "Skull's" Rainbow Room plus see and learn so much more. If you hear the sound of a small dog barking behind you and, turning to investigate, find nothing there, you may want to quicken your pace. Old "Skull" just might be looking for the perpetrator of his demise and mistakenly think it is you!

The Ghosts of Tootsie's Orchid Lounge

Located on what is commonly known as Honky Tonk Way (legally known as Broadway) in downtown Nashville is a famous country western bar by the name of Tootsie's Orchid Lounge. Mom's was the original name of Tootsie's, but Tootsie Bess purchased the bar in 1960 and changed the name. She was a well-known singer and comedienne who performed with Big Jeff and the Radio Playboys and was married to the bandleader, Jeff Bess.

Tootsie claimed that the name Orchid Lounge was added after she hired a painter to paint her bar. When she arrived later that day the place was painted orchid in color, hence the new name. Tootsie took to the color with a passion, and most of her wardrobe, cars and anything else she owned was orchid in color.

The world famous Ryman Auditorium, the original Grand Ole Opry, is located directly behind Tootsie's, separated by an alley. Because of its location, Tootsie's became a place of refuge for most of the famous stars who performed at the Grand Ole Opry. Famous customers included Kris Kristofferson, Faron Young, Tom T. Hall, Mel Tillis, Roger Miller (who wrote the song "Dang Me" in the bar about all of his exploits there), Waylon Jennings, Patsy Cline and Willie Nelson (who received his first songwriting job after singing his original songs in Tootsie's). Charlie Pride gave Tootsie a jeweled hatpin that she used to stick unruly patrons.

Several movies were partially filmed at Tootsie's such as *W.W. and the Dixie Dance Kings* starring Burt Reynolds and *Coal Miner's Daughter*, the autobiography of Loretta Lynn starring Sissy Spacek, Tommy Lee Jones and several other notable actors.

Tootsie was not well-known but was well loved in the community of country music. She would employ many of the down-on-their-luck writers

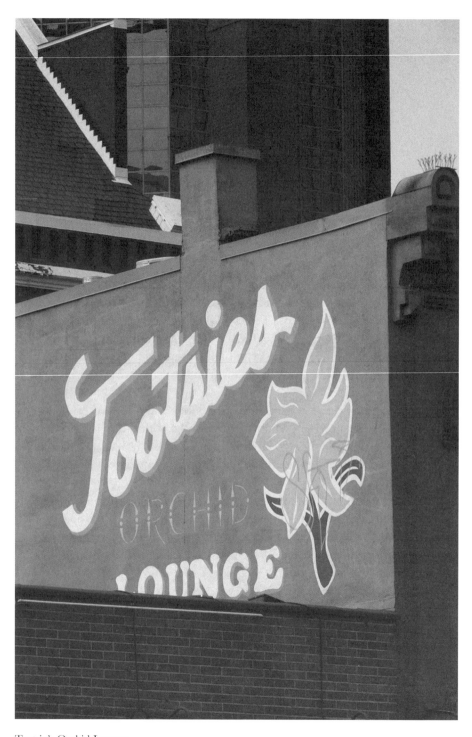

Tootsie's Orchid Lounge.

and entertainers so they could support their families. She would often feed them while they worked and slip them a five or ten dollar bill on their way out for the evening. She kept a cigar box full of "IOU's" under the bar, and at the end of the year the grateful Grand Ole Opry performers would get together to pay off these debts so she could keep her doors open.

Many an autographed photo and other memorabilia were donated to Tootsie's by those performers she helped out. To this day they are all still there, lining what Tootsie called the "Wall of Fame," which she immortalized in song herself.

When Tootsie passed away she was buried in an orchid colored dress, in an orchid colored coffin with an orchid in her hand. Many of country western's famous figures attended her funeral.

But that's enough history—now for the legends surrounding Tootsie's Orchid Lounge.

One of the most enduring legends is that of Hank Williams Sr. He literally has been seen performing hundreds of times on the front stage of the bar. Tootsie's was his favorite hangout and watering hole after he performed at the Opry. He would sneak out of the side door of the Opry and make a mad dash across the alley and into Tootsie's.

One patron was lucky enough to encounter Hank Sr. in the alley and got a picture of him appearing in a long sleeved, white shirt, slacks and cowboy boots. Another picture shows Hank Sr. as a plasmic mist appearing on the front stage of Tootsie's. It so resembled Hank that a national magazine ran the picture.

Many other famous artists that have gone from this realm have been spotted at Tootsie's. Roy Acuff, Ernest Tubbs, Patsy Cline and many more love to return and can be heard performing on that front stage, usually late at night.

It is often said by patrons who knew Tootsie Bess that they can sense her presence and smell her favorite perfume, but when they whirl around fully expecting to see Tootsie once again, she is never there.

When visiting Nashville, I encourage you to pay a visit to the world famous Tootsie's Orchid Lounge. You just might be treated to a couple of old Hank Williams Sr. songs or perhaps some songs by another one of your favorite old artists.

The Famous Legends of the Original Grand Ole Opry/The Ryman Auditorium

The Ryman Auditorium has a very long and rich history. It was built originally as a church by Captain Thomas Ryman, later became an entertainment venue and then the Grand Ole Opry from 1943 to 1974.

Captain Ryman was a man of considerable wealth having made his money as a riverboat captain and as the owner of a line of riverboats and gambling operations that plied their trade on the Cumberland River. On May 10, 1885, he and a group of his cronies decided to attend a weekly revival meeting conducted by Reverend Samuel Jones. Their intention was to have some fun at the reverend's expense by heckling him during his service. Instead Captain Ryman became a convert to religion.

Ryman worried that his immoral past as a womanizer and drinker of some repute might impede his chances at getting into Heaven. In order to rectify this situation, he decided to spend some of his wealth on building Reverend Jones a beautiful and permanent sanctuary.

Originally named the Union Gospel Tabernacle, construction began in earnest shortly after Ryman's conversion, and the first revival was held within its unfinished walls in May 1890. The tabernacle was completed in 1892. The seating capacity at that time was 1,255 people—quite a large church for its day. In 1897 a balcony was added, an addition which brought the seating up to its present day capacity of 3,755 seats. The balcony was originally named the Confederate Gallery in honor of the Confederate Veteran's Convention held in conjunction with the Tennessee Centennial Exposition. The church was constructed for a staggering sum in those days of $100,000.

On December 23, 1904, Captain Ryman died and at his funeral Reverend Jones took a vote to rename the tabernacle the Ryman Auditorium, which it remains to this day. Reverend Jones continued to preach there until his death in 1906. A memorial service was held in his honor on October 28th of that year.

The Famous Legends of the Original Grand Ole Opry/ The Ryman Auditorium

Shortly after the reverend's death the auditorium became an entertainment hall for such notables as Sarah Bernhardt, John Phillip Sousa, Teddy Roosevelt, Carrie Nation, Mary Pickford, Douglas Fairbanks, Charlie Chaplin, Will Rogers, Rudolph Valentino, Isadore Duncan, Doris Day, Katharine Hepburn, Bob Hope, Harpo Marx, Elvis Presley and later his daughter Lisa Marie to name a few.

Films partially shot at the Ryman include *Coal Miner's Daughter*, *Honkytonk Man*, *Sweet Dreams: The Patsy Cline Story*, *Nashville* and *Big Dreams and Broken Hearts: The Dottie West Story*. Johnny Cash filmed his national television show from there.

The Ryman Auditorium continues to be a venue for all types of acts from rap to country, rock and jazz and is considered the second-best hall acoustically in the United States, after the Mormon Tabernacle in Salt Lake City.

Interesting place and interesting history, but that is only scratching the surface. There are a number of ghost legends connected to the Ryman.

The first is the legend of Captain Ryman himself. It was said that when Ryman converted to religion he became so devoted to his religion and his auditorium that when he passed away he did not cross over to the "other side." He was known for being very strict about the activities that were held in the Tabernacle during his life, and it seems that he decided to remain the ongoing monitor of all events and activities in the Ryman after his death as well. It is said that he would highly disapprove of any act that he considered sacrilegious, and at one such event he made so much noise that the audience could not hear the performance. He thrashed about and ran up and down the aisles until either the performance ceased or the customers simply left in disgust because they could not hear anything.

Another legend concerns a group called the Crew that came to perform at the Ryman. After their performance, they were engaged in conversation with some of the stagehands from the auditorium and heard about the legends of the place. Being very skeptical they dared the staff to let them stay there overnight to prove to everyone that the legends were totally false.

The next day, by phone, they reported that all had been quiet until around midnight when suddenly they heard footsteps echoing through the theater. They were sleeping under an area called the Gallery, and the footsteps were loudest right above them. As the footsteps came closer they saw dust floating down from the joints between the boards of the floor.

They yelled out but received no response. Warily, they ran up to the Gallery and found nothing there but the sound of the footsteps still reverberating in the dark, vacant theater. In fear they fled the building and returned to New York. They have not been back to perform at the Ryman since.

Ryman Auditorium.

The third legend is that of Lisa Marie Presley and her father, Elvis. Some years ago Lisa Marie and her band appeared at the Ryman. After a successful performance, Lisa Marie and her entourage made their way from the backstage area down to her dressing room. One of her bodyguards reached the door first and went to open it for her and the others, but found it to be locked. Thinking this strange since no one was supposed to be in there, he attempted it again. It still did not budge. Angrily, he yelled to whomever was inside the room to unlock the door, but no one responded. With the help of another bodyguard he leaned against the door to try and force it open. It gave slightly, but it felt like someone was leaning on the door from the inside to counter their attempts. Suspecting someone from their tour or some overzealous fan that had snuck past security and slipped into the dressing room, they yelled once again for whomever was holding the door to immediately release it.

From out of nowhere, and to everyone's shock and amazement, came the undeniable sound of Elvis himself, laughing. Not a single person present doubted whose laughter it was, for several members of the group had been part of Elvis's team and knew him well. Even Lisa Marie's mouth fell agape, and her face went pale as she remembered the sound of his laugh from her childhood.

Lisa Marie has repeated this story several times in interviews and on television and is convinced that her father had come to see her perform that night. The dressing room episode was his way of letting her know he had been there.

The fourth legend is one of the longest running stories concerning spirits in the Ryman. The legend is called the "Gray Man." Many feel that the "Gray Man" is an old Confederate soldier who perhaps had attended one of the Confederate Veteran's Conventions at the Ryman and so loved the placed that upon his passing he decided to remain there. Since the auditorium became an entertainment venue, the "Gray Man" has been seen up in the balcony watching the rehearsals for the different acts that appear there. What is odd is the fact that he has never been seen at an actual performance. He has also never been found when specifically searched for—he simply disappears into thin air.

The most endearing legend to most fans is that of Hank Williams Sr. Hank so loved the Grand Ole Opry that it is said that he returns to the auditorium on a regular basis to perform once again on the stage that represents his delivery into country music fame. Many of the Ryman employees have reported over the years that when they are about to lock up for the night and head out the door they hear a Hank Williams Sr. song start to play. At first many of these employees were confused as to where the song

was coming from, and they would set off to investigate the source. Surely, someone must have turned on a boombox or radio in the building. But alas, no source could ever be found.

After a while this became a fairly regular event, and at times the source could be pinpointed to the stage area. Several employees have reported observing a mist-like appearance that resembled Hank on the stage at the time his song was heard. For the employees who haven't been scared off by this occurrence it is a delightful opportunity to once again be privileged enough to attend a Hank Williams Sr. performance. As mentioned in the Tootsie legend, Hank would always make his way out of the side door of the Ryman into the alley and quickly dash across to his favorite watering hole.

When in Nashville I urge you to take a tour of the original Grand Ole Opry at the Ryman Auditorium. If you suddenly see a gentleman in gray or hear a Hank Williams Sr. song coming from nowhere do not be alarmed, as you have just been privileged enough to have been visited by the most famous spirits still residing in the old auditorium.

The Spirits of Merchant's Restaurant

Around the corner from Ryman's Auditorium at Fourth Avenue and Broadway is a great eatery called Merchant's Restaurant. Originally built in 1892 it was primarily used as a pharmacy. It was the very first pharmacy in the downtown area of Nashville. Eventually it became a swank hotel and was host to many of the famous country western stars of the day before becoming a fine dining restaurant.

During its pharmacy days, the owner hired his son-in-law to help him run the business. One afternoon the pharmacist searched the building looking for his son-in-law but for about twenty minutes could find him nowhere. Where could he have gone? This was most unlike him to simply disappear—he was a very quiet and rather sullen young man who kept mostly to himself while going about his tasks and duties.

Finally, in exasperation, the pharmacist made the trek up to the third floor where extra supplies were kept. When he arrived he was mortified by the sight before him. There in one of the front windows of the third floor was his son-in-law, dangling from the end of a makeshift noose. Eyes and tongue bulging, neck broken and arms quite swollen, it was crystal clear that he was dead. The boy left no note to explain his sudden and disturbing suicide.

To this very day the staff and customers of the Merchant's Restaurant report a lot of very strange and unsettling events. Employees who have to go to the third floor to retrieve supplies for the business report many of these events. It is common for the area to feel very cold, even in the sweltering heat of summer. Objects will often be moved from one side of the room to the other, even though someone had been there only a few minutes before and could verify their original placement. Employees over the years have had a sickening feeling in their stomachs after being up there, certain that someone had been watching and following them.

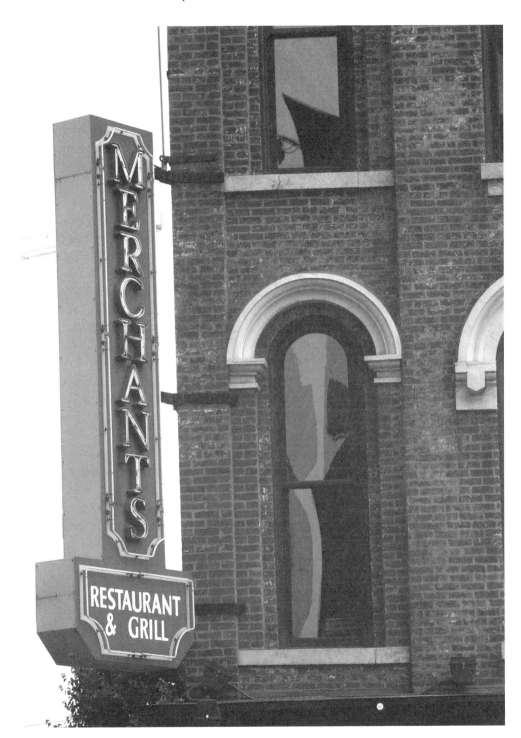

Merchant's Restaurant.

On the first and second floors, where guests dine and drink, the spirit will often blow his cold breath on the back of the necks of servers, as if taking pleasure in their subsequent antics. The server will usually jerk around rather quickly to see who is behind her, only to find herself staring at nothing or looking directly into the startled face of a guest. Often accidents have occurred due to this behavior—many plates have been dropped and beverages spilled on an unwitting guest. A number of employees have quit due to these ghostly pranks. He must delight in that fact as he continues to perform them to this day.

Reported over the years is another event far more gruesome than that of harmless little pranks. Visitors to the Honky Tonk Way of Broadway have reported that when passing by on the opposite side of the street from the Merchant's Restaurant they would be scared to death to see a man hanging lifelessly in the third floor window. Often rushing into the restaurant breathlessly to report what they had just seen, they would be confused at the lack of reaction from the staff. What was even harder for most of these people to accept was the fact that they were told that it happened all the time and that no one was really hanging up there.

Distrustful of what she had been told, the frightened witness often demanded to be taken up to the third floor to see for herself. Upon entering the room she would report that it was rather cold but that there was no one hanging from the window. Looking around suspiciously, the witness would often feel as though an evil prank was being played on her. Searching frantically about the area she would finally give up and retreat back to the street, only to be left with the frightening image of an invisible hanging man haunting her thoughts.

It is said that one such witness to this phenomenon became so irate that she went screaming out of the restaurant and straight to the police station to report that not only had she seen a man hanging from the third floor window, but that it was obvious to her that there was a massive coverup by the employees of the business. This was not the first time that the police had been beseeched by a hysterical visitor trying to convince them that a heinous crime or suicide had occurred and that there was a sinister plot to cover up the details by the employees of the restaurant. Motives suggested for such a coverup have ranged from widespread complicity in a murder to callously not wanting to taint the reputation of the restaurant.

I highly recommend Merchant's Restaurant. I have personally partaken of their fare, and not only is the food excellent, but so is the service. With a little luck you just may get to witness one of those common ghostly pranks, as your server suddenly jerks around to find only empty space behind her.

Bon appetit!

Legends of the Ernest Tubb and Lawrence Record Shops

Just a few doors down on the same side of the street from the Merchant's Restaurant is located a very famous set of record stores. Ernest Tubb Record Shop has been there for sixty years and Lawrence's Record Shop almost as long. Of course, if you are a fan of bluegrass or country western music then you will recognize the name Ernest Tubb as one of the all-time greats and a member of the Country Music Hall of Fame. What makes these businesses particularly interesting is not the fact that they sell records and CDs, but the paranormal activity that they are both famous for.

The entire row of buildings on this block has been there since before the Civil War and was used extensively during the war as a hospital and morgue. The basement underneath the Ernest Tubb Record Shop was primarily used as a morgue because it was cooler than ground level and the bodies would not rot as quickly before interment.

When the original Mr. Lawrence was alive and running his business he was fond of smoking cigars. One of the most common occurrences in Lawrence's today is how often customers will report smelling cigar smoke in the establishment. The employees are rather used to it, but firmly assure the customers that they don't allow smoking inside and that it must be something else they smell. After all, who would believe them if they told the customers they were just experiencing a visit from the cigar smoking ghost of the late Mr. Lawrence?

Two doors down at Ernest Tubb's, a whole different set of occurrences arise with some regularity. Many times when the employees are discussing a certain country performer the CD player will suddenly start to play music by that artist. More than a couple of customers have been perplexed by this incident, especially after being told by the employees that the artist's music is not in the CD player at the time.

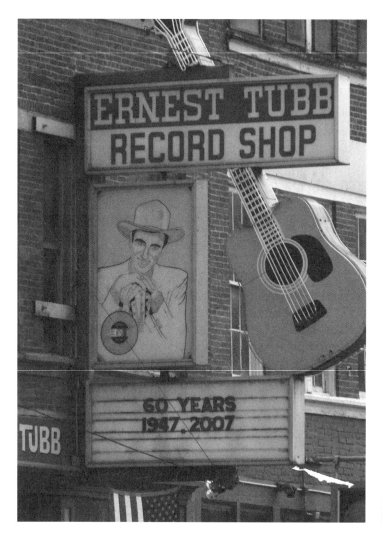

Ernest Tubb
Record Shop.

Another common event is for visitors to feel cold spots in the store—a sure sign of paranormal activity. But the spookiest place of all is the basement, the site of the old Civil War morgue area previously mentioned. Many employees have reported feeling faint, sick to their stomachs or lightheaded while down in the basement. Additionally, many employees need to wear a jacket or sweater to enter the basement as it is always significantly colder there than on the main floor.

When in downtown Nashville be sure to visit two of the most famous record shops in the country. And if you're feeling particularly brave while browsing Tubb's shop, ask the staff if it would be possible for you to take a trip into their basement—alone.

The Ghost of the Maxwell House Hotel

On the edge of the Men's Quarter at the corner of Fourth Avenue and Church Street there used to be a hotel called the Maxwell House. For years it was considered one of the most prominent hotels in all of Nashville, hosting in its grand ballroom elegant parties, banquets and political rallies. Construction began just prior to the outbreak of the Civil War, and it was used as a prison during the war. The hotel was completed shortly after the end of the war.

At least eight U.S. presidents stayed at the Maxwell House, enjoying the hospitality that had become legendary. They included Rutherford B. Hayes, William Taft, Woodrow Wilson and Teddy Roosevelt. When Roosevelt tasted the hotel's coffee he proclaimed it "good to the last drop" and launched the slogan still in use today. Other visitors of note were Thomas Edison, Henry Ford, Annie Oakley and William Sydney Porter (better known as O. Henry).

The original Maxwell House burned to the ground on Christmas Day 1961 after almost a century of operation. The current building that stands in its place was originally built as a bank and now operates as a hotel.

There is an enduring legend surrounding the Maxwell House site that originated during the Civil War and continues through this day in reports from hotel guests. Originally, the Confederates confiscated the building and retained it for only a short time before they were driven out of Nashville by the Union army. Union forces used the hotel for a number of purposes, including a hospital and officers' quarters.

Two brothers were assigned to guard the building, and they had always been very close. Unbeknownst to the two, they were both courting the same beautiful, young southern belle. The young lady encouraged the affections of both brothers, but instead of turning against the young lady when they

eventually discovered the truth, they turned on each other and a bitter hatred grew between them.

Since both brothers were assigned to the same company and the same tasks they were forced to spend a lot of time together, much to their dismay. On a particularly lonely and chilly night one of the brothers snuck the young lady into the building. Thinking they were alone, the two grew intimate when suddenly, from out of nowhere, the other brother appeared. A violent argument broke out and accusations of betrayal soared.

At some point during the heated argument one of the brothers withdrew his knife and attacked the other, slicing his throat from ear to ear and then stabbing him multiple times in the chest. The young girl screamed and attempted to stop the violence, but in a fit of rage he stabbed her multiple times as well. Trying to cover up the heinous crime the remaining brother wrapped the dead bodies in a blanket and pulled them down the stairs one at a time. He dragged the body of the young girl down first to the bottom of the stairs and then returned to get his brother's body. He got about halfway down to the first floor when suddenly the stairway collapsed. The building had never been completed, and these stairs were only temporary ones to allow access to the upper floors. Both bodies, living and dead, crashed down to the first floor killing the living brother instantly.

To this very day it is often reported by hotel guests that they will hear the sound of two men arguing violently on the upper floors. If a guest is brave enough to investigate this disturbance he reports feeling a sudden cold chill in the air and catching a glimpse of a beautiful young woman before she dissipates into thin air. It is believed that she is the young southern belle in search of her two suitors.

I recommend getting a room at the hotel located at the corner of Fourth Avenue and Church Street, sipping a great cup of coffee and taking in the history all around you, both normal and paranormal.

The Legends of Fort Nashborough

In 1780 the settlers that had dared to venture so far west erected a fort for protection against Native American attacks on the bluffs of the Cumberland River. Named in honor of General Nash who had fallen in Germantown, Pennsylvania, on October 4, 1777, during the Revolutionary War, the settlement was originally named Nashborough but was later shortened to Nashville. The title and honor of being the founder of Nashville fell upon Colonel James Robertson who was born in 1742 in Virginia and died in Tennessee in 1814.

There was a famous Native American battle that occurred on April 2, 1781, known as the Battle of the Bluff. On that fateful day a force of Chickamaugans Cherokee led by their chief, Dragging Canoe, attacked the fort at the bluffs. The attack succeeded in luring most of the men from the fort to chase the Cherokee, but only caused the white settlers to be cut off from the entrance. The men were able to escape back to the fort but paid a heavy price as the Cherokee captured most of their horses. One of the main reasons that the men were able to return to the fort was the fact that the women had let all the dogs loose to attack the Native Americans.

Dragging Canoe had sworn that he would make the white man pay a heavy price if they moved into his land and he kept his word. He was upset by a treaty that some of the other native chiefs had signed that sold their valuable hunting grounds in the area surrounding Nashville to the white settlers. During the negotiations Dragging Canoe had predicted that this would bring about the extinction of the Cherokee. He refused to consent to the agreement and warned that he and his warriors would fight for the land. This he did with furor.

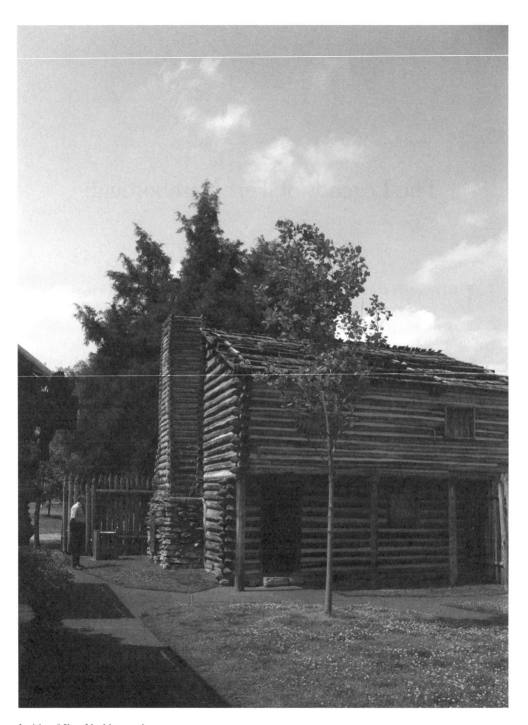

Inside of Fort Nashborough.

Many settlers died at the hands of Dragging Canoe and his warriors over the next fourteen years. All of this violence and death has had an everlasting effect upon the area.

One of the more common reports of the paranormal is that of barking dogs heard in the vicinity of the fort's entrance. Many a visitor has reported the sound, but on further investigation not a single dog has ever been found. Also heard frequently is the sound of women yelling, telling the dogs to attack the Cherokee. Some swear it sounds like it has been recorded and is playing through speakers inside the fort, but this is not the case. In addition, there have often been reports of the sighting of what is obviously a Cherokee war party, whooping and hollering at the top of their lungs as if attacking the fort.

This is an anomaly in the paranormal realm known as an imprint. Imprints occur on a regular basis and can be either seen or heard, depending upon the circumstances. This most interesting and unusual event occurs in the same area on what appears to be a timetable. When imprints occur visually one can see the event taking place, and the characters in the imprint appear to be totally oblivious to anything or anyone around them.

Due to its long Native American and Civil War history, Nashville retains the dubious distinction of being one of the most haunted areas in the country. Not only is Nashville the capital of country music and the state of Tennessee, but it is also the capital of haunted areas in the United States.

The Spirits of the Mooreland Mansion

In 1836 a beautiful southern mansion was built in the Nashville area known as the Mooreland Mansion. The Moore family had constructed it in the grand style of the old south and threw many lavish parties there. The Moores had an eighteen-year-old daughter named Ruth. Ruth was to be married in the mansion, and on the eve of the wedding her parents threw an extravagant reception. The year was 1855.

In her dark blue party dress, especially made for the occasion, Ruth looked beautiful with dark hair and dark eyes. The reception was attended by everyone who was anyone in Nashville society, so the house bristled with a tremendous amount of activity. At some point during the evening Ruth made an exit to retrieve something from her room. After an unusually long time she had not returned. Concerned, her mother scurried off to fetch Ruth from her room.

Upon entering the room she found Ruth lying on the floor at the foot of her bed, dead. Her neck had been broken.

Ruth's mother reeled backwards from the room, tripping over her own feet and falling to the floor. Finally managing to compose herself enough to utter a sound, she started screaming and wailing like a wounded animal. Everyone in the house froze in fear at the sound of her cries. Rushing upstairs, they found Ruth's mother, white as a sheet, sitting on the floor pointing into Ruth's room, all of the blood drained from her body.

Rushing past her a half-dozen guests dashed into the room only to be horrified by the sight of Ruth's lifeless body. Some reeled out of the room, others retched, and it took several minutes for anyone to compose himself enough to reenter the room.

Immediately, the talk turned to whom could have possibly done such a horrendous thing. Soon a list of all the guests was being scrutinized for possible suspects, but no one could identify a single potential perpetrator.

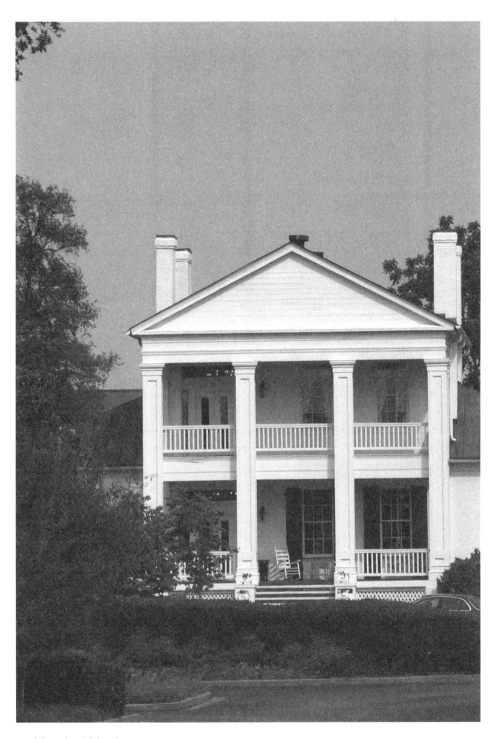

Mooreland Mansion.

There was one name, however, that came up at some point during this amateurish investigation. It was the name of a young man who had deliberately not been invited to the reception or the wedding the following day due to the fact that he had been a prior suitor of Ruth's and had widely proclaimed his heartbreak at Ruth choosing another. His demeanor and actions had become sullen and dark as of late, so many in the area considered him a prime suspect. But after an extensive investigation, neither the thwarted suitor nor anyone else in the community was ever formally charged with Ruth's murder.

Before becoming an office building (which it is today) the mansion was a private residence. A number of past owners have reported the presence of a young woman in the house, both visual and verbal experiences. One such owner, who was a total skeptic when she first moved into the mansion, had been told of the legend of Ruth as well as several others that have persisted over the years. She said that she quickly became a believer because of all of the strange events that occurred during her time there.

In one case the woman reported that her maid had beckoned her into one of the long hallways to see for herself that there was truly a paranormal presence there. The owner observed footsteps, obviously those of a woman with small, delicate feet, left behind on the still-wet floor that the maid had just mopped. Instantly the owner's response was that someone must have followed behind her after she mopped. But the maid asked her how she could explain the fact that the footsteps started in the middle of the hallway and not near any door and then discontinued about four feet from her mop bucket. There were no return footsteps.

The owner was quite perplexed as it was yet another event in an ever-growing list of occurrences that had no real explanation.

Some of the other events the owner observed or witnessed were items falling off shelves for no obvious reason, windows being left opened (especially the ones that were stuck shut and could not be opened by humans in spite of vigorous efforts) and lights that came on at will, often right in front of her, when there was no one else in the room.

After a while every time the owner came into the house she would address Ruth, telling her that she was home, did not mean any disrespect and would appreciate it if Ruth did not show herself physically to the owner as this would be more than she could bear. Ruth always honored the lady's request and never showed herself.

Now that the mansion has become business offices, Ruth apparently likes to have a little fun with the employees. It has become almost impossible to keep any cleaning staff for very long as she has visually appeared to many of them. Because paranormal events like this occur on a regular basis,

The Spirits of the Mooreland Mansion

the best the tenants can hope for now is to get several cleaning company employees to go into the mansion after hours together and, staying very close together, lightly dust, empty the trash, clean the bathrooms and do a very fast vacuuming in order to exit the building as quickly as possible.

One such cleaning person tells the story of how she was dusting and sweeping the stairways leading to the second floor when she suddenly sensed someone's presence near her. Looking up she saw Ruth in a pink dress pointing out several spots she had missed. Terrified, the cleaning lady bolted, calling her employer the next morning to say that she would not be returning to work.

An attorney who occupies one of the offices in the building has reported that a number of times he has been hit in the back of the head with a bottle of white-out. He has gotten somewhat used to it but says it is still very annoying. Another incident that the attorney cites is hearing on more than one occasion his secretary scream bloody murder. After calming down she insists that she just saw a Civil War soldier walk through the reception area. No one is too surprised by this as the whole area is rife with legends concerning soldiers from the Civil War, both Confederate and Union.

One of the businesses that is located today in the Mooreland Mansion is an insurance company. If you ever find yourself in Nashville and in need of some insurance be sure to stop by to discuss your needs with one of the agents. During your consult, you might just catch a glimpse of Ruth or one of the wandering Civil War soldiers.

53

Ghosts of Dillard's

Located in the Green Hills Mall is a Dillard's department store. It has been for many years the location of a number of very strange and inexplicable events of the paranormal type.

As mentioned in the previous story, it is not unusual to hear tales of Civil War soldiers throughout Nashville considering the Battle of Nashville and the number of soldiers that were both stationed and died in the area. However, it *is* unusual to hear about the sighting of a Revolutionary War soldier, since Tennessee hosted no action during that war. But as strange as it may sound there are constant sightings of just such a soldier, and of all places, he has taken up residency in the Dillard's department store.

One employee recounts the story of how he spotted the soldier for the first time in the stockroom. This employee worked in the shoe department, and the original sighting occurred right at Halloween, which might explain why everyone he told the tale to just laughed it off as seasonal jest. Things changed, however, when another employee reported seeing the soldier fling rows of purses off several tables and strew them across the floor. Another employee reported hearing someone calling her first name in the stockroom, and when she went to see who it was, she came face to face with the soldier.

An employee in men's sportswear was cleaning up the dressing room area at closing time one evening when he saw the shadowy figure of someone behind the slatted doors of a dressing stall. Informing the person that the store was closing and he needed to proceed to the cashier to make any intended purchases, the employee was greeted only by silence. Figuring the man did not hear him he moved closer to the dressing room door and repeated himself a little louder. Still, there came no response. The employee at this point figured someone was playing a practical joke on him, perhaps another co-worker, so he pushed open the door and was stunned to find the

apparition of the Revolutionary soldier. Reeling backwards into the door of the dressing stall, he crashed through it, breaking most of the slats.

A captain of the Nashville Metropolitan Police Department remembers the time that he was employed as a security guard at Dillard's due to a malfunctioning alarm system. At about 1:00 a.m. he reports that he spent the rest of the night chasing down a voice that he could never find. Figuring it had to be coming from a video or music system that had been left on, he went to the control room for all of the store's electronics only to find that all systems had been shut off, as they should have been. At first he felt that the sound had to be coming from somewhere else in the mall, perhaps through the ventilation system. He had heard of things like that happening before, but his belief soon changed when he encountered the soldier face to face in the store itself. This was only one of a total of six sightings of the soldier that the police officer made that night. Although he still contends that he is not a believer in "that sort of thing," he says he has to admit that he cannot explain what he saw or heard that night.

Another employee reports seeing the leg of the soldier disappear into a wall on several occasions. He describes the soldier as dressed in an ivory, linen-like, blousy shirt, brown breeches and a boxy cap, holding a musket and usually standing there expressionless for a moment before he simply dissipates. One of the scarier events for this employee was the time that he was bent over trying to remove a staple from the sole of a shoe when he sensed someone staring at him. Looking up he encountered the soldier glaring down at him. It appeared for a brief second that he was about to say something but then suddenly the soldier disappeared. For the first time the employee said he was frightened.

There are many other employees who have witnessed odd events in the store concerning the soldier, but they refuse to admit to them publicly as they fear retribution and ridicule from their fellow co-workers or supervisors.

If you are a frequent shopper at Dillard's, then by all means drop by the one in the Green Hills Mall in the south Nashville area and check out their great selection of clothes and products. I promise you that they have something you will not find in any of their other stores: a real Revolutionary War soldier.

Happy shopping!

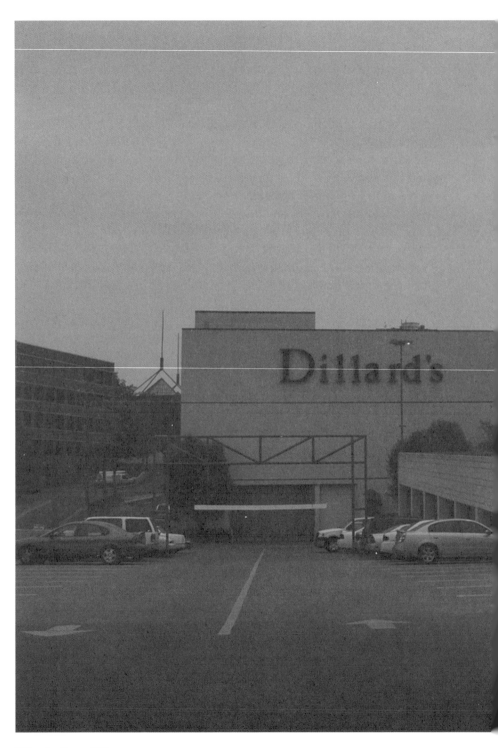

Dillard's, Green Hills.

The Haunting of Hurricane Mills/ Home of Loretta Lynn

The grand dame of country music, Loretta Lynn, is certainly no stranger to the paranormal realm and in fact has spent most of her life surrounded by the presence of spirits. Although not noted for her psychic ability or paranormal experience, her prowess in this field is legendary.

From a very early age Loretta could predict events before they happened. At the tender age of fourteen she was pregnant and married to her childhood sweetheart. They moved away from her family and home, and she quickly became extremely homesick. Her earliest recollection of her psychic ability was being able to predict when her mother was expecting a letter from her, and she could predict to the day when she would receive one from her mother. This occurred for years. Loretta even predicted her father's death when she visualized him lying in a coffin one night in a dream. The next day she was informed he had died the night before of a massive stroke.

In 1967, after having achieved great fame in the country western singing world, Loretta and her husband decided it was time to look for a larger home. One day, while driving west of Nashville in the country, they became lost on a back road and happened upon a beautiful old plantation house that they knew instantly was perfect for them. They weren't even sure if the house was for sale, but much to their delight it was and soon they were moving in.

Almost immediately upon moving in the family started noticing many strange occurrences. The adjoining door between Loretta's bedroom and the bedroom of her twin daughters would open and close on its own. The twins would often mention to their mom that they saw people in their room. One of the more common people the twins saw were women dressed in old-fashioned dresses with their hair piled high upon their heads. Also seen in the house were Confederate soldiers as well as what appeared to be slaves that once worked the plantation.

The Haunting of Hurricane Mills/Home of Loretta Lynn

Loretta found out shortly after moving in that there had been a Civil War skirmish on the property and that nineteen Confederate soldiers were buried there. This seemed to explain the sightings of the soldiers in the house.

Another unusual feature of the home was the "slave pit" located underneath the front porch. During the time of slavery it was used as a place of punishment for disobedient slaves. They would be placed in the pit and shackled with chains that were secured to the foundation of the house.

One night Loretta said she and a friend were watching television when suddenly they heard a person walking across the front porch. They went to the door to see who it was but found no one there. When they returned to watching television the sound started up again. This time there was an additional sound along with the footsteps—the sound of a chain being dragged across the porch. They tried to ignore the noise but soon realized that it was coming directly from the slave pit. Loretta has long since come to accept the presence of the tormented slaves and no longer pays any attention to them.

On other occasions Loretta has felt cold chills and shocks as if someone has just passed through her. She has often heard something or someone going up and down the stairs, and the pictures that line the wall along that staircase are stubbornly crooked, strangely resistant to her attempts to straighten them.

Eventually, Loretta tried to make contact with the spirits that resided in her house. On one occasion, during a séance, a table moved all the way across the room under its own power. At another séance Loretta and several friends made contact with a spirit who called himself Anderson. The group, naturally, grew curious and wanted to ask Anderson many questions, but he became extremely upset and began to violently shake the wooden table they were using. Without warning the table then jumped up quite high into the air and crashed to the floor so hard that it broke in two.

The next day Loretta spoke to several of the local residents in town to see if they had ever heard of anyone named Anderson in the area. It turned out that the original owner of the plantation was a gentleman named James Anderson and he had died and been buried on the property, fairly close to the house. Loretta has never tried to contact that spirit again.

When visiting the Nashville area I recommend taking a trip a good way west out of town and visiting the home of the world famous Loretta Lynn. Be sure to ask to speak to James Anderson—just don't do it if you are standing close to any heavy furniture.

Have a pleasant visit!

The Legends of the Adelphi Theater

Located near the state capital is the Tennessee Performing Arts Center, more commonly called TPAC. Nashville has always had a love of theater, extending back to the early 1800s. The original theater that stood where the current TPAC building is today was known as the Adelphi Theater, and it opened on July 1, 1850. The theater ran a series of Shakespeare plays when it first opened.

Around this time a family renowned for its flair in the theater arts came to Nashville. The patriarch of the family was a gentleman named Junius Booth. He was an actor with a very recognizable name for his time. Junius had two sons whose reputations would soon rival their father's for their work in theater.

All of the Booth children save one were born out of wedlock, and the eldest brother and sister raised their younger sibling. Later they would both write of their little brother's eccentric behavior. His name was John Wilkes Booth. Though this name is now inextricable with the term assassin, J. Wilkes Booth, as he was known professionally, led a very prominent life as an actor prior to his notorious act. In a biography of Booth written in 1929, the author states that Booth launched his career in theater in 1855 in Baltimore and began performing on a regular basis two years later.

During a two week engagement in Nashville in February 1864 Booth performed the prodigious feat of starring in thirteen different plays. He already had a reputation as an outspoken advocate of the southern cause, but he was still highly regarded by northern audiences and received generally favorable reviews wherever he went. A critic for one of the Nashville newspapers wrote that he could not commend Booth because he was too violent, but in general the young actor was favorably received both on the stage and in the city.

A little more than a year after his performance in Nashville Booth produced his own tragic drama when he assassinated President Lincoln at Ford's Theater in Washington, D.C.

Booth was a staunch proponent of the southern way of life, and many feel that he has returned to Nashville and the current day TPAC in his afterlife because of his political beliefs and the warm reception he received when he performed there.

TPAC employees often report hearing strange sounds emanating from the stage area after the regular performance has been finalized for the evening. The sounds are similar to those of a man performing as an actor upon the stage. Sightings of this man have been mentioned from time to time, and most everyone agrees that this apparition bears a strong resemblance to John Wilkes Booth.

One now infamous story involves a stage manager who worked for many years at TPAC before his retirement some years ago. He reports that he came to work early one afternoon, as was his custom, to start preparing the stage for that night's performance. He had been diligently working for almost an hour when there came from stage left a sudden sound, as though something had crashed to the floor. Figuring that one of the stage lights had come down, the manager rushed to the area to assess the damage. To his surprise, he could not locate anything out of place and certainly found no broken stage light.

"How strange," he thought to himself, for the sound was as real as anything he had ever heard. Certainly something or someone had caused the noise and, determined to find the source, he continued to search the backstage area. Finally admitting defeat, he discontinued his search and returned to his tasks to ensure that everything would be in place for the impending start of the performance.

Not twenty minutes later he was startled from his concentration by the voice of a man coming from the center of the stage. Certain that this time he was not imagining the sound, he wondered which of the actors had snuck past him to the stage to rehearse lines for that evening. He suspected one of the new actors, probably trying to calm his stage fright at what was most likely his first time appearing in front of a live audience.

In no hurry to see who the nervous actor might be, the stage manager finished his task and casually walked to the edge of the backstage area to watch the player as he continued to execute his lines. Onstage stood a man dressed in an unusual costume of a long, black, old-fashioned suit jacket and pants. Though the play scheduled for that evening was a modern day piece, the manager shrugged off the actor's odd fashion choice and began to listen more intently to his words. Was that Shakespeare he was reciting? Upon





closer study, the manager ascertained that is was, indeed, Shakespeare. This struck him as even more odd than the man's unusual clothing selection. He began to wonder whether this man was even supposed to be here. Perhaps he had snuck into the theater to act out some thespian fantasy in which he was a famous actor performing a celebrated scene before an unseen, admiring audience.

The stage manager decided he had no more time to waste and determined to tell the stranger that he would have to leave. As he approached from behind, the man—so obviously engrossed in his performance—did not hear him draw near. Not wanting to startle him, the manager called out softly but to no avail. He tried raising his voice, but still the actor ignored him. Frustrated, he reached out to touch the man's shoulder to get his attention, but to his shock and disbelief his hand slipped right through the man's body. As the manager staggered backwards in fear, the actor turned and looked at him blankly, as if to acknowledge his presence and at the same time express irritation at the interruption. The manager's heart pounded as he noted the actor's undeniable translucence.

Beginning to think that he was crazy or hallucinating, the manager tried to run off the stage, but his feet felt like anchors and he found himself paralyzed in his tracks. Suddenly, the actor smiled a very wry smile, and without any apparent effort, he simply disappeared. Overcome with a terrifying mix of relief and shock, the manager sat down on the stage in an effort to compose himself. Finally gathering his wits, he walked to the staff room and found his assistant who had just arrived for work. Claiming illness, he asked him to fill in for him that evening and headed for home. A short time later the stage manager retired. Now whether his retirement was due to this incident is unclear, for he never mentioned the event again after repeating it one time to his assistant.

If you are a patron of the theater, or simply looking for a wonderful night out on the town, I recommend seeing a play at the Tennessee Performing Arts Center in downtown Nashville. Perhaps you will be privilege to a very special performance by one of the most infamous characters of our time.

Enjoy the theater!

The Ghosts of the Melting Pot Restaurant

One of the most popular areas of downtown Nashville is in the vicinity of Broadway and Second Avenue. This area is filled with many nightclubs and great restaurants. One of particular note is the Melting Pot Restaurant. Specializing in fondue fare, it is often reserved for months in advance.

Several years ago a tragic double suicide occurred in the basement of the restaurant. Two young employees fell in love with each other, but their love was forbidden by both sets of parents. The parents felt that their children were far too young to be this enamored with each other, so they forbade them to see each other after work. But, as anyone who is so in love would do, the two continued their romance in secrecy and were eventually caught by a parent. The young lovers were told that the girl would have to quit her job and that her whereabouts would be closely monitored from that point on.

Both became extremely depressed, feeling they could not live without each other. Like Shakespeare's star-crossed lovers, the young couple decided to take their own lives. Finalizing their plan, they met at the restaurant and slipped into the basement undetected by any of the other staff. Their lifeless bodies were later discovered lying close to each other, hands touching.

They say that true love is eternal, and it must be for the two lovers remain together in the basement. Staff at the Melting Pot consistently report seeing one or both of them when they have to go into the basement for supplies. One of them usually appears to the employee peering out from behind a stack of boxes or a shelf, looking nervous at the prospect of discovery for fear of retribution from their parents. Many of the staff report that the young girl appears to be crying with tears streaming down her face. Other times she appears to be angry. Often the two will turn the lights on and off in the basement. On several occasions the restaurant brought in their electrician to check out the wiring in the basement, but it was always found to be functioning normally.

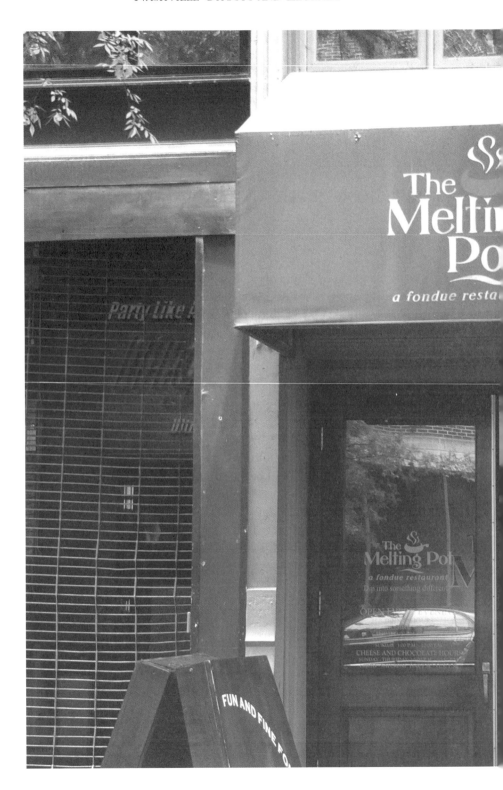

Melting Pot
Restaurant.

Not too long ago a group of four women friends were dining at the restaurant and had heard of the legend of the lovers. They asked their waiter whether there was any truth to the story, and he assured them that he himself had seen both young lovers on several occasions. Becoming even more curious and still somewhat skeptical, the ladies asked to see the manager. They asked if they could possibly go into the basement to see for themselves what this was all about. To their surprise they were granted permission and after the meal the manager escorted them to the basement. As he left them to explore, he asked only that they turn off the light at the top of the stairs when they exited.

In just a matter of minutes the lights began to flicker on and off. At first the ladies thought that a trick was being played on them, but when they looked to the top of the stairs where the light switch was located, the landing was empty and the door was still shut. The ladies remained in the basement for another ten minutes or so but did not see or hear anything else unusual. Somewhat disappointed, they decided to leave.

As they started to depart, one of the ladies who had bought a harmonica for her grandson extracted it from her purse and held it up at arm's length. She spoke rather softly, asking that if anyone was present to please play the harmonica. Her friends must have thought this a rather strange act, but they were transfixed on that harmonica as one single note resounded in the dark.

The group wasted no time making their exit.

If you've worked up an appetite for some wonderful fondue I urge you to make a reservation at the Melting Pot on your next trip to Nashville. Retire to the basement after your meal, and perhaps you, too, will meet Nashville's own star-crossed lovers.

The Spirits of Mount Olivet Cemetery

Just outside of downtown Nashville is a cemetery known as Mount Olivet Cemetery, one of the largest and oldest cemeteries in the area. It is the final resting place for many famous people of Nashville such as William Bate (governor, 1883-1887), John Catron (U.S. Supreme Court justice), Frank Cheatham (Confederate general), Thomas Frist (co-founder of Hospital of America and father to Senator Bill Frist), Thomas Ryman (steamboat captain, businessman and builder of Ryman Auditorium) and many others. The cemetery has continuously operated since its initial establishment in 1856. There is also an area in the cemetery called Confederate Circle, which honors those who served on the Confederate side in the Civil War. About 1,500 soldiers are buried there. Mount Olivet also has one other unique distinction—it is well-known as a place that hosts many paranormal events.

Mount Olivet is the best location in the Nashville area to experience one of the more unusual paranormal events called black abbeys. Usually associated with churches (though not always), black abbeys are black, shadowy figures that glide through an area doing the same thing every time they are seen.

One of the better-known tales about the black abbeys comes from a caretaker who worked for many years at Mount Olivet. He related this story to anyone who would listen right up until his own death some years ago. One summer evening he was working late to prepare for four funerals scheduled to take place the following day—an unusual number for a single day. His duties were to oversee the digging of the gravesites, making sure they were located in the correct spot, and to assure that the crews were doing their jobs piling and covering the dirt properly, setting up the receiving tents, lining up chairs and executing any other special requests by the funeral home

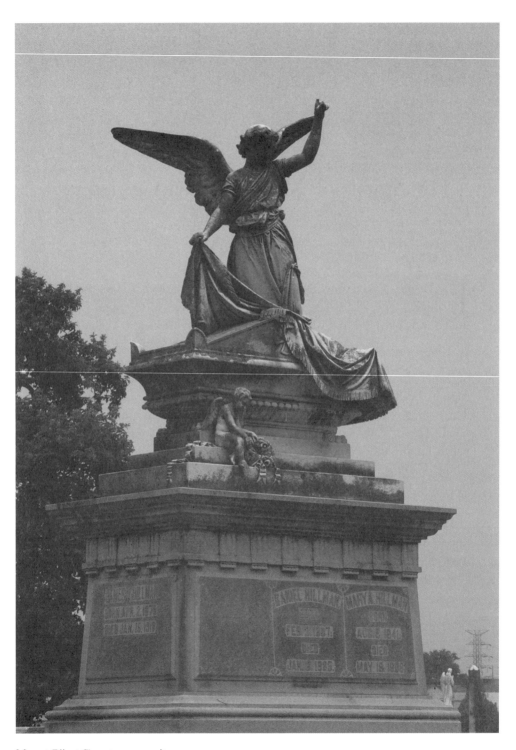

Mount Olivet Cemetery gravesite.

for the clients. The job lasted well into the night and, finally finished and exhausted, the caretaker headed to his little office located on the grounds to put away his things and head home.

He was approaching his office when something caught his attention out of the corner of his eye. Thinking one of the workers must have forgotten something, he glanced over in the direction of the movement. What he saw not only startled him but also caused him to break into a cold sweat. There, gliding rather rapidly between some of the gravestones, was a black, shadowy figure. The caretaker called out to the figure, but it paid him no attention. It continued its trek through the headstones, and just as suddenly as it appeared, it disappeared.

Legs giving out, the caretaker fell to the ground like a sack of potatoes. His mind reeled with questions—what had he just witnessed? After a few minutes that felt like hours, he pulled himself to his feet and staggered to his office where he gathered his things and made his way home.

The next day he called in sick and spent the entire time in bed, playing the eerie experience over and over in his mind. He came to the conclusion that what he had witnessed was not simply deceptive lighting or a trick of the eye and that he would have to accept the reality of the situation. Although he came to accept the event as a paranormal experience, he was never entirely comfortable alone in the cemetery late at night.

An image resembling Captain Tom Ryman of Ryman Auditorium fame has also been sighted in the cemetery. Captain Ryman was a riverboat captain and owned a number of boats that plied their trade on the Cumberland River. He was also a well-known businessman in Nashville as mentioned in the legend of Ryman Auditorium. It is reported that his image can be seen strolling through the cemetery as though surveying a piece of property he was contemplating purchasing. This event is very likely what is known in the paranormal field as an imprint, as it occurs on a regular basis, and Ryman does exactly the same thing every time without any awareness to his surroundings.

If you enjoy traipsing through old cemeteries I encourage you to visit Mount Olivet, as it is quite beautiful and unique. But if you stop by late at night, you might just find that you are not the only visitor.

Enjoy your visit!

The Ghosts of Union Station

After a short drive back into downtown Nashville we arrive at the site of our next legend, Union Station. Once home to as many as eight different railroad lines, Union Station was a very active hub in Nashville right up to the end of World War II. It consistently bustled with activity day and night as thousands of passengers scurried to and from their destinations.

Train travel began to decline rapidly after the war as the United States became an automobile society and moved farther and farther from cities into suburbia. By 1970 Union Station was abandoned and fell into ruin. Some years later it was purchased and renovated into a luxury hotel still in operation today, but many hotel employees will tell you that for some it has never stopped being a railroad station.

Legend has it that on nights when a full moon makes its monthly appearance a ghost train pulls into the old station to conduct business. Both employees and guests have reported hearing the sound of a train's whistle off in the distance.

There are primarily two ghosts that appear at the station. One is a woman believed to have been killed under the iron wheels of a train during an exceptionally busy time. The other is a World War II soldier who stands on the old platform area looking up and down the tracks as though trying to find a way home. No one knows how the soldier met his demise, but it is clear that there is something at the station that keeps him from moving on.

Years ago, an employee had an interesting encounter with both the soldier and the woman on the same night. She was on night duty and took a break to go outside and have a smoke. Lighting up, she inhaled deeply and let out the smoke in a long, slow exhale. As the cloud of smoke drifted lazily upwards she noticed a woman standing off in the distance. "Amazing," she thought, "the way images can appear in smoke and how easily the imagination runs wild with those images."

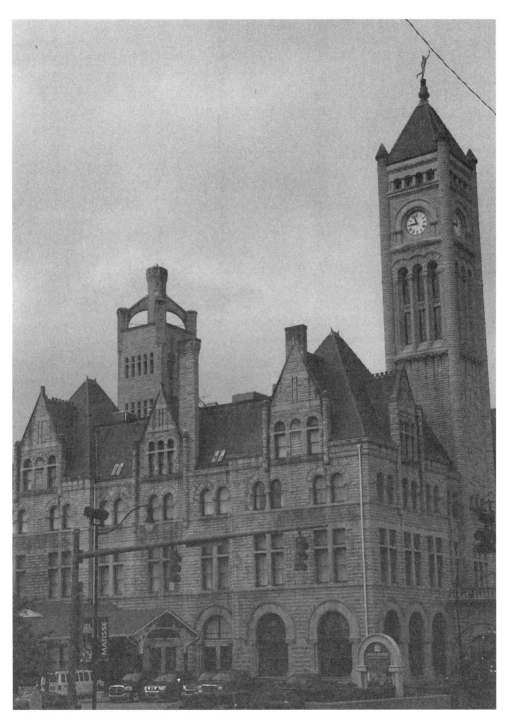

Union Station.

But as the smoke slowly disappeared, the woman remained. Startled, she dropped her cigarette, feeling silly that what she had assumed was an image caused by the smoke was actually a human being. The woman, who was very neatly dressed, stared at the employee from a distance of about ten feet or so. Her expression was blank but laced with some kind of sadness.

Thinking perhaps this guest needed some directions or information, the employee started to ask if there was anything she could assist her with. As her mouth opened, the woman turned sharply and plunged from the platform onto the old tracks. Aghast, the employee lunged forward to try and help her. When she arrived at the point where the woman had jumped, she peered down at the tracks but they were empty.

"Impossible!" the employee thought, certain that she had seen the woman jump. Frantically, she looked up and down the tracks, not only out of concern for the woman but also fearing for her own sanity. After a futile search, the employee returned to her job at the hotel, visibly shaken by the experience. When a co-worker asked her what was wrong, she replied that she just felt a little ill at the moment, but was sure that it would pass.

Busying herself at the reception desk, her mind was pulled away from the strange event and to the task at hand. She kept up the busy pace for the next two hours, and by the time she was ready for another smoke break, her nerves had calmed down to normal. Feeling like her old self again she returned to the platform area for a much-needed cigarette. Once again inhaling deeply she felt all remaining tension leave her body. Still, she found herself examining the smoke for signs of the woman but was relieved to find herself alone with her thoughts. Lazily inhaling and exhaling, the employee casually glanced up and down the platform area. She began to drift deeper into her thoughts when something caught her eye from the left. Turning her head she saw a soldier standing on the platform about twenty feet away. His back was to her, and she observed him with mild curiosity. They rarely had soldiers stay at the hotel for it was quite expensive, and she knew that soldiers didn't make a lot of money.

The soldier turned his head back and forth, scanning the tracks for a minute before twisting his neck to scan in the other direction. He repeated this action over and over, and the employee wondered what it was that he was searching for. Perhaps he was meeting someone on the platform? She was about to finish her cigarette when the soldier suddenly dissipated into the night. The employee started, convinced that she had finally gone mad.

Several employees inside heard her screams and rushed out to see what was happening. They found her huddled up against a column, flailing her arms about wildly, screaming at them to stay away. After quite some time she seemed to calm down, crumbling the rest of the way to the ground. She had passed out from the ordeal.

She was rushed to the hospital, sedated and placed in a room. When she came out of the sedation she was extremely disoriented. The nurse told her what had happened and suddenly she became very frightened, remembering the events from the previous evening. She started to ramble to the nurse, describing the events as she recalled them. Of course, the nurse was quite skeptical and began to feel that perhaps this lady should be held over for some psychiatric evaluation.

After her release from the hospital, the hotel employee moved away from Nashville and has never been heard from again.

I recommend that you visit the old and very beautiful Union Station, now a five-star hotel, and relive some of Nashville's lively past. If you see or hear anything out of the ordinary coming from the platform area of the old train station, just ignore it. After all, we all know there is no such thing as a ghost.

Enjoy the experience!

The Legend of Belmont Mansion

This legend contains a great deal of grief and sadness. A lady by the name of Adelicia Hayes married a wealthy businessman in the Nashville area, and they had four children together. The marriage ended after just seven years, and all four children died by the age of eleven.

In 1849 Adelicia married for the second time and gave birth to twin girls. The couple built a beautiful home and called it Belmont Mansion. It was built in the style of an Italian villa surrounded by elaborate gardens. Since there were no public parks at the time in Nashville, Adelicia magnanimously opened up the estate so that the citizens of the area could bring their children to picnic and play. Adelicia loved the sound of children on her property as it helped relieve some of the grief she still felt over the four children she lost.

Life was very good for Adelicia and her family until the Civil War broke out and her husband joined the Confederate army. Tragically, he was killed in a battle, and shortly after his death Adelicia's twin girls died of scarlet fever.

Her third marriage was held at Belmont Mansion. Adelicia did not have any children by this marriage. In 1887 she sold Belmont and moved to Washington, D.C. It was reported that Adelicia was a very sad and lonely person as she constantly mourned her dead children and husband. Not long after her move to Washington she died of what many believe was a broken heart. Her body was brought back to Nashville for burial.

The Belmont Mansion is now the center of Belmont University. As you can imagine there is a good amount of security at the university, and it has often been reported by the guards that Adelicia can be seen gliding around the area of her home, scurrying from one side of the mansion to the other, looking as though she is worried about something. She will occasionally

set off a motion detector in her travels. Keeping security guards at the university remains a challenge due to Adelicia's activities. One particular guard shared the story of his experience with Adelicia some years ago, and to this day he refuses to set foot back on the property.

The guard had come on duty around midnight and clocked in for his shift. He was new to the position, only having been there a week. He set out to complete his first round of inspections for the night when he was startled by a group of university kids who came running around the corner of a building and nearly collided with him. The guard queried the kids as to what was going on, and one of them breathlessly related what they had just seen. Apparently the kids were coming back from an evening of fun in town and passed close by the Belmont Mansion on their way back to the dorms. On the front porch they saw a lady dressed all in white, and it seemed as though they could see right through her. As the kids were commenting to each other about how the light behind her must be causing this effect, Adelicia started toward them. She didn't walk down the stairs. She simply glided towards them and actually passed through one of them.

The air became cold around them. Terrorized, they tried to run, but felt like their legs were made of cement. They had been looking in the direction of the porch for any more signs of the strange woman but saw none. When they turned around, Adelicia glided right through the group once again. It was at this point that somehow they regained the use of their legs and sprinted as fast as possible away from Belmont Mansion.

Listening to all of this the guard thought he was being made the butt of a joke—everyone knew there was no such thing as ghosts. He did have to admit, however, that it was a most convincing performance. The guard asked the group if they wanted to take him to the exact spot where this event occurred, and in a unified response they all said, emphatically, "No!"

He assured the kids that he would investigate and sent them back to their dorms. He had no intention of falling for their prank, and he continued in the normal direction of his rounds. He wanted to make sure that if the kids did follow him they would see he had not been duped. As he made his rounds, he found nothing out of the ordinary. His normal route did not bring him by the mansion, and at the end of his round his curiosity got the best of him. He checked around to make sure the kids had not followed him, and confident that he was alone, he decided to go and check out the Belmont Mansion.

Arriving at the mansion he went to the front porch area, and as he suspected, there was absolutely nothing out of the ordinary. Snickering and congratulating himself on not succumbing to their prank, he turned and started back to the security office. He had not walked more than a dozen

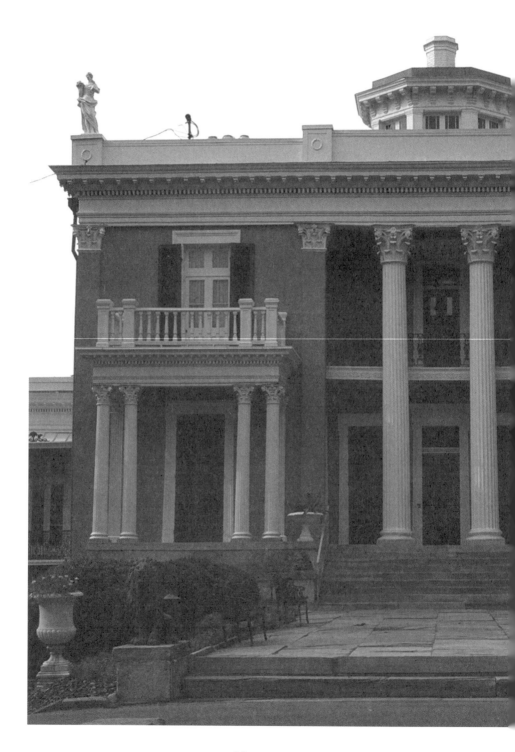

Belmont Mansion.

steps when immediately in front of him appeared Adelicia, dressed all in white and completely transparent, just as the kids had reported. She had a sad look upon her face, and it appeared as though she might have been crying for her eyes looked very moist.

The guard said he couldn't move and felt like a character in a horror movie. His mind raced at such an incredible speed that he was convinced it would explode. Then, all of a sudden, he realized that he had not moved and neither had Adelicia. Slowly he turned and bolted for the security office where he grabbed his personal things, knocking over items in his haste, and scrambled to his car in the parking lot.

Driving as though in a drag race, he nearly clipped several other cars in the lot as he fled the area. Continuing at insane rates of speed on the city streets, he finally snapped out of his terror and realized what he was doing. He pulled over and collapsed against the steering wheel, soaked in sweat and physically shaking from the whole ordeal.

He sat in his car for some time and contemplated what had just occurred. Reluctantly, he admitted to himself that he had just seen a ghost. He would later say that his encounter with Adelicia made him a believer in the spirit realm. But he never wanted to have another experience with the paranormal again.

After this and a number of other incidents concerning Adelicia, the university secretly brought in a psychic from another area of the country to see what she could find out about Adelicia. They made sure that the person they used had no knowledge of Adelicia or her past. The psychic spent about two hours in the old mansion and then wrote a report of her findings. She noted that she had definitely encountered a spirit being in the home and was told that her name was Adelicia, a rather unusual one indeed. She reported that Adelicia was fearful that her once beloved home would be torn down to make room for more buildings on the university campus. The psychic also wrote that Adelicia wanted to find her children. When she asked Adelicia how many children she had, Adelicia told her that she had six, that she loved each and every one of them very much and could not understand where they had gone. Adelicia told the psychic that she was always sad because she could not locate her children. The psychic was only told afterwards about the six children and how they had all died young.

Belmont University is a renowned school and well worth a visit, so please stop by the campus the next time you're in the area.

I bet you will have a new and different appreciation for higher education now!

The Unholy Spirits of
the First Presbyterian Church

In the heart of downtown Nashville sits a most beautiful house of worship, the First Presbyterian Church. Built between 1849 and 1851 by the architect William Strickland who designed many other buildings in the area including the state capitol, the church is considered to be one of the finest examples of Egyptian Revival architecture anywhere in the world.

During the Civil War the Union army confiscated the church as well as many other buildings in the area and converted it into a military hospital. The name they assigned to it was Hospital No. 8. It housed 206 beds and literally hundreds of soldiers died there, many without the luxury of any kind of drugs or painkillers, so you can imagine the tortured deaths they experienced.

There is a legend concerning a young man who was told of the soldier spirits that still remained at the church. He had a real interest and was a true believer in the paranormal. He requested permission from the church to spend the night to see what he could experience. He was denied his request as a matter of policy.

Undeterred, the young man went to visit the church late one afternoon shortly before it closed and was locked up for the night. As he hoped, he was the only one in the sanctuary. He found a secure place to hide and waited for them to come and lock the doors. A short time later he heard the caretaker locking up the doors that gave egress and ingress to the main sanctuary. Staying concealed for about another thirty minutes he finally peered around the corner of his hiding place to make sure he was all alone. Satisfied that he was, he emerged, feeling both nervous and exhilarated, and picked out a location amongst the pews to take up residence for the night that would allow him to observe his surroundings easily.

He mentally patted himself on the back for having laid out his plan so well and for remembering to bring some snacks and water with him.

Glancing at his watch, he found that it was still early in the evening, so he settled down in the pew with a book. Aided by a flashlight so he could see to read, he also felt more comfortable about being able to see whatever might occur around him in the total darkness.

He drifted off to sleep and was startled awake, sitting bolt upright. In a daze and foggy from his slumber, it took him a few seconds to remember where he was. Looking at his watch he realized he had been asleep for almost four hours. Coming to his senses he surveyed his surroundings but could see nothing but the total darkness around him.

He reached down beside him to get his flashlight, turning it on to scope his surroundings and, at first, did not notice anything unusual. Feeling hungry at this point and in need of a drink he reached down to the floor to retrieve his backpack that contained his things. But it was no longer there. With flashlight in hand he scoured the area, even getting down on his knees to look under the benches. But his backpack was gone.

Frightened, he scampered back into his pew and sat in silence, certain that he was not alone in the church. He was met with a deafening silence that hung like a heavy fog. He felt his throat tighten as his fear became more pronounced, and he worried that he might choke to death if he did not get some relief soon.

Relief soon came in the form of a sound like thunder reverberating in the cavernous church, but he soon realized it was only footsteps approaching him. "So I'm caught," he thought. He waited for someone to turn on the lights or scold him for sneaking into the church after hours. When nothing happened, his fear amplified. He felt paralyzed for some time, but finally managed to find his flashlight again and turn it on. The light gave him confidence.

At first he saw nothing, but as he moved the beam of light around the church's interior, he observed what appeared to be a mist. He rapidly moved the light across this area, and the mist took on a very definite shape, that of a Union soldier carrying a musket over his shoulder and a backpack on his back. The soldier moved across the front of the church where the preacher's podium and choir pit were located. He appeared to be marching as if in a drill.

The young man sat motionless and transfixed by what he saw. He kept the light fixed on the soldier. It was as though the soldier did this on a regular basis, as if it was his duty to guard the church.

Though he was nervous and frightened the whole time this was going on the young man said he never felt threatened in any way. He felt that he was a privileged witness to this occurrence and did not want it to end, but it finally did. The soldier marched around the church for almost forty-five minutes before finally vanishing into the air.

The young man has visited the church many times since, but never again after hours. His fascination with the church, the soldier and his own memories of the event keep him returning on a regular basis, often to simply sit in a pew and contemplate his experience.

If you enjoy old architecture I urge you to visit the First Presbyterian Church in downtown Nashville, for it is truly beautiful. You can take pleasure in the uniqueness of the structure, and you just might receive a spiritual revelation of the paranormal type.

Happy hunting!

The Ghosts of the Hermitage Hotel

The Hermitage Hotel, located downtown at the corner of Sixth Avenue and Union Street, was Nashville's first million dollar hotel opening its doors for business in 1910. The finest materials were used in the construction of the hotel—Italian marble, wall panels of Russian walnut, a cut stained-glass ceiling in the vaulted lobby, Persian rugs and overstuffed furniture. The Hermitage became the preferred gathering place for the city's socialites, as well as the national platform for both the pro- and anti-suffrage forces.

A national radio program that introduced a young singer and Nashville native by the name of Dinah Shore was broadcast from the hotel's famous dining room. Some notable patrons of the hotel include six U.S. presidents, Greta Garbo, Bette Davis and even the notorious gangster Al Capone. It was and continues to be a popular lodging for country western superstars. The most famous pool player in the world, Minnesota Fats, lived at the hotel for eight years before he passed away. He had his own pool table on the mezzanine and would regularly challenge other hotel guests to a game.

Like most old buildings the Hermitage has a long and rich history, which makes it a prime site for stories and legends. Staff and guests throughout the years have reported a number of unusual events, ranging from a lady in white to a baby crying in room 910 to the sighting of famous, deceased former hotel guests.

The appearance of a lady dressed all in white is one of the more common reports. She is said to appear from nowhere and casually make her way down a hallway where she simply disappears by walking right through a wall.

Some years ago a housecleaning employee was working on the sixth floor one afternoon, cleaning her assigned rooms. The hotel was nearly empty as it was off-season. Engrossed in both her work and her own thoughts,

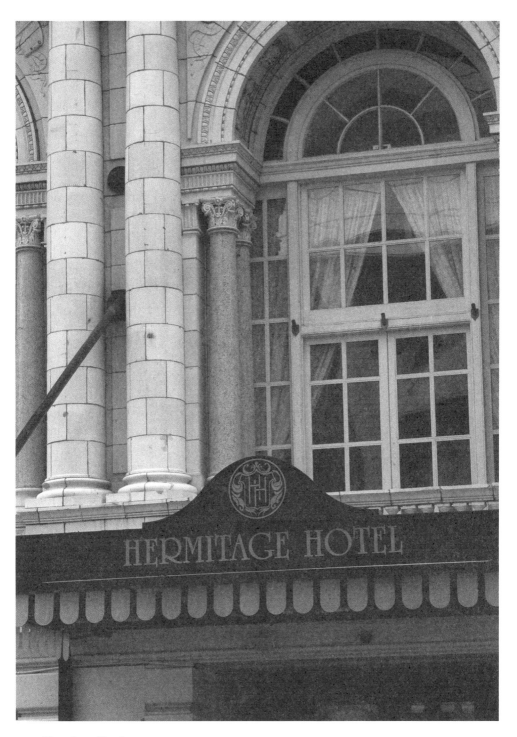

Hermitage Hotel.

she wasn't paying any particular notice to her surroundings. Suddenly, a woman dressed all in white walked into the room, went into the bathroom and slammed the door shut. Startled by the sudden, loud noise, the cleaning lady nearly jumped out of her skin. Composing herself, she approached the bathroom door and knocked lightly. Receiving no response, she knocked again, this time louder. Again, no one answered.

Growing frightened, she worried that the lady might have entered the bathroom with ill intent. Stepping quickly from the room she beckoned to a co-worker and friend who was working at the other end of the hallway. The co-worker could see that her friend was in a panic and hurried to her aid. When she asked what was wrong, the first lady pulled sharply on her friend's sleeve and dragged her into the room. She whispered into her ear that someone was in the bathroom and would not respond to her knocking. The co-worker approached the door cautiously with her friend close behind and pounded rapidly on the door, demanding that whoever was in the bathroom come out immediately. They were met with a chilling silence.

Deciding that she had had enough nonsense, the co-worker turned the door handle and to her surprise the door opened easily. Jumping back, both women tumbled to the floor. Gathering themselves, they peered into the bathroom and found it to be empty. Glaring at her friend, the co-worker told her she did not find this kind of practical joke amusing. The first lady swore to her she was telling the truth—there was no way the door could have slammed like that on its own. Unconvinced, the co-worker stood up, brushed herself off, turned sharply and went back to her job.

The cleaning lady was both shaken and embarrassed, but she remained convinced that she had seen a lady in white go into the bathroom. The fact that the bathroom was empty when she and her co-worker opened the door left only one other explanation, and she wasn't ready to accept it. She abruptly quit that afternoon and never returned to the hotel.

Another common report involves the sound of a baby crying in room 910. This only occurs when the room is vacant and every attempt to find the source of the crying has proved futile. The staff has become so accustomed to these reports that they no longer bother to investigate.

Many people report seeing famous past guests of the Hermitage still wandering its hallways. Patsy Cline is often heard singing one of her world famous songs. At first most guests think it is a recording being played over a PA system but when they inquire with the front desk they are told that, as a matter of policy, the hotel does not play music in the lobby area.

Minnesota Fats must still make visits to the hotel he called home for so many years as guests report hearing someone playing pool on the mezzanine. There is no longer a pool table on the mezzanine level.

The Ghosts of the Hermitage Hotel

One gentleman made a frantic report to the front desk one evening. He was relaxing in the beautiful lobby area when suddenly he heard the very distinct sound of a rack of billiard balls being broken for the opening shot of a game of eight or nine ball. Being an avid pool player himself, his interest was piqued. Listening closely, he determined that the sound was coming from the mezzanine area right above his head. He headed for the elevator and ascended to the next level, eagerly anticipating an exciting evening of billiards.

Entering the main mezzanine area he looked around for the pool table, but found it nowhere. "How strange," he thought, certain that he could still hear the unmistakable sound of pool balls being hit and falling into leather pockets. He decided that the pool table must be located in another area of the hotel, and he had simply misjudged the origin of the sound. Undeterred, he reentered the elevator and descended to the lobby floor. He walked to the middle of the lobby to listen for the familiar sound and locate its position. The sound was so distinct, and yet he could not determine from where it came.

At that moment another hotel guest walked passed him, and he asked the man if he knew where the pool table was located. The guest replied that he was unaware of any such thing in the hotel, adding that he was a frequent visitor. By this time the sound had stopped—perhaps the game had ended.

He decided to go back to the mezzanine area, convinced that he had simply overlooked the pool table. It must be in an alcove he had missed. He searched the entire mezzanine to no avail. Perplexed, he turned to leave when suddenly, sitting in a chair, there appeared a rather heavyset man holding a pool cue. "At last!" the man thought. He had found the right area. He approached the seated man, who looked strangely familiar, and asked if he could join in a game. The fat man looked bemused and smiled at him before he rose. He walked a short distance, turned and disappeared into the wall.

In disbelief, the man approached the wall and felt it with his hand. It was solid, as it should have been. Frightened, he stumbled backwards and fled the area as quickly as possible. When he reached the lobby he headed straight to the reception desk and began babbling that he had just seen a pool player walk into a wall. After calming the man down, the clerk shared the story of Minnesota Fats and how he had lived in the hotel for many years and kept a pool table on the mezzanine. The man was skeptical—could he really have seen Minnesota Fats? He was assured that he was not the first guest, and would certainly not be the last, to report such an incident.

If you enjoy staying at the finest hotels when traveling, I encourage you to reserve a room at the Hermitage Hotel in downtown Nashville. But don't be fooled if you hear the sound of billiards, for it is only Minnesota Fats taking another sucker for his money up there on the mezzanine.

Rack 'em up!

The Haunting of the Capitol Records Building

At the turn of the last century a local businessman by the name of Jacob Schnell built a grandiose mansion in Nashville, in an area now referred to as Music Row. It was Jacob's fervent wish that his daughters be accepted into Nashville high society, but the city's elite crudely snubbed them. After Jacob's death, his daughters let the mansion fall into total disrepair, and it crumbled bit by bit into ruin while they lived inside. Some say this was their way of taking revenge for the snubbing they received, forcing the upper crust to endure the deterioration of the mansion as it sat beside so many other fine homes.

After both women passed away Capitol Records purchased the property and had the old mansion torn down. In its place they erected a building for their business. Once construction of the building was complete, many of the employees started to report strange events such as objects being moved from one location to another, doors being locked from the inside, tampering with the recording equipment, lights being turned on and off, toilets being flushed and windows being opened after they were locked. There were also reports of two women walking around the hallways and then suddenly disappearing.

For a long time Capitol Records found it difficult to keep employees. As they quit, employees would tell their supervisors that they could not get used to the strange events and were particularly shaken by the sightings of the Schnell daughters. One employee simply walked off the job, leaving behind all of her personal possessions, and never returned. She was a new hire and was just getting used to the routine when her world was turned upside down.

On the particular day in question, the new employee was at her desk, going about her normal tasks. Concentrating intently on a particularly

Capitol Records building.

complicated task, she was completely lost in her own world. At first she was only slightly conscious that something seemed to have moved on her desk. Shaking off the feeling, she continued to work.

When her stapler suddenly fell to the floor she was startled back to reality. She stood up to see what had fallen and bent down to pick it up. When she did, a number of papers she had been working on blew off the desk and fell to the floor. Standing bolt upright, she whirled around to see which one of her prankster co-workers was causing all the commotion, but she was alone in the office. Her second thought was that she had left a window open, and a gust of wind was the culprit. But then she remembered that it was hot outside and the air conditioner was on so the windows were all tightly closed.

Growing annoyed, she began to gather the stray papers. Behind her one of the filing cabinet drawers sprang open, and when she turned toward the noise her chair moved towards the office door. Her annoyance giving way to fear, the employee collapsed, shaking, to the floor. She began to cry, convinced that something terrible was about to happen to her. Her mind would not focus and all of the events seemed to blend together. She felt as though she was being engulfed by some chaotic and terrifying dream.

Managing to compose herself, she rose slowly from the floor and made a feeble attempt to straighten her disheveled appearance. She bolted straight for the office door, out to the parking lot and into her car. That was the last anyone ever heard from her.

Shortly after this event a psychic was brought in to investigate. Her report concluded that there were two sisters living in the building who were filled with incredible sadness.

Another Capitol Records legend comes from a night security guard who had the fortunate (or unfortunate, depending on your view) luck to view the daughters. His report log shows that he had been on duty for approximately two hours when he set off on his next series of rounds. Everything appeared in order, as he expected.

As he entered a long hallway in the building he noticed something at the other end of the hall. Disappearing around the corner before he could really focus on whom or what it was, he picked up his pace to get a closer look. No one had checked into the building on his shift so he knew he was supposed to be alone. Feeling slightly nervous, he withdrew his oversized flashlight for protection.

As he rounded the corner at the end of the hallway, the image disappeared around yet another corner. This time he yelled out for whomever it was to stop. He hustled down the hall and around the corner and there, about ten feet in front of him, floated the two ghost-like images of the Schnell

daughters. He later described them as wearing old-fashioned dresses that reached to the floor with ruffles around the collar and at the end of the sleeves. Both women seemed transfixed, swaying slightly back and forth as if blown by some invisible breeze.

Backing away slowly, the terrified security guard rounded the corner, but to his dismay the spirits followed him. Paralyzed in fear, he tried to escape, but felt as though he was pushing his way through chest deep water. Every time he glanced over his shoulder the spirits were right there behind him. Eventually, he reached the front door, unlocked it and fled to his car. It was only once inside the vehicle that he was able to catch his breath. He glanced about wildly, afraid the daughters had followed him, but was relieved to find that he was alone in the parking lot.

Trembling, he could barely hold onto the keys as he fumbled to insert them into the ignition. Finally, he was able to fire up the engine and, without releasing his foot from the gas pedal, he slammed the transmission into gear and the car shot forward, spinning the rear tires. The car swerved back and forth nearly colliding with several other vehicles as he fled from the parking lot in a panic.

If anyone runs into the security guard please let him know that he is welcome back at Capitol Records at any time. The Schnell daughters in particular seem to have taken a particular liking to him.

The Tortured Spirits of Old Donelson Hospital

About a decade ago one of the oldest hospitals in Nashville closed its doors. The building still stands and is used primarily as record storage for other hospitals and doctors' offices.

It is commonly reported by those who visit the old hospital to retrieve records that once the door closes the sound of screams and moans can be heard off in the distance. The closer you get to the old psych ward, the louder the tortured sounds become. Often footsteps can be heard in the hallways when no one is present, or there is a strange clanging sound behind the walls.

The psych ward emanates a definite feel of high energy, and the temperature is very chilly, even in the middle of summer. Reports have been consistent about the appearances of poltergeist in the building. They always appear in white hospital gowns. It is rare that anyone will venture into the building alone, and once inside most employees will not separate.

There are two legends that seem to have stood the test of time and continue to circulate amongst those familiar with the old hospital.

The first concerns a psych patient that resided in the hospital for many years. He was a particularly difficult patient and a nightmare for the staff, suffering not only from schizophrenia but also from multiple personality disorder. He had as many as eight personalities, and depending on which one manifested at any given moment, he could go from very docile to extremely violent often with no advance notice. Only long-term staff were allowed to deal with him and always with two large orderlies present. When he did become violent it would take all of the strength of the two orderlies just to restrain him, and at times they had to call in additional orderlies to help strap him down. For safety reasons, he was kept separate from the rest of the psych ward population.

Donelson Hospital.

Over the course of his stay two people had the misfortune of meeting up with the man in an unprotected environment. The first was another psych patient who unwittingly wandered into his room. No one was ever quite sure how the gate in the hallway outside the man's door or the door to his room came to be unlocked. But when the man saw the hapless patient walk into his room it sent him over the edge and he violently attacked. At first he beat the patient with his fist and then turned to using a chair on him, hitting him so many times that the chair finally broke into pieces. The man then took a broken chair leg and with the sharp end began to stab the patient over and over from head to toe.

No one heard the commotion, but one of the staff members noticed that the hallway gate was open, and he rushed down to the room and peered through the window. He was horrified at what he saw. There was blood splattered all over the floor, walls and furniture. The patient's chest was ripped open and some of his organs had been ripped from his torso and tossed about the room. The man was sitting in the corner with a wild, glassy-eyed stare, muttering something to himself. Screaming for additional help, the orderly summoned another five co-workers to help him subdue the man.

Several years later a long-term nurse at the hospital was dispensing the man's medication with the two mandatory orderlies at her side. The man seemed to be in one of his docile moods and was lying on his bed. The nurse was preparing the medications when without any warning the man leaped from his bed and grabbed her from behind. In a matter of seconds he had the nurse by the head and sharply twisted it to the left, snapping her neck and killing her instantly. It happened so quickly that the orderlies could do nothing to save her. They were finally able to subdue the man and placed him in a straightjacket.

About a year later, the man was found dead in his bed under very suspicious circumstances. It appeared that someone had probably poisoned him, but there was no real investigation into the matter. No one mourned his death.

The man's screams and moans are thought to be the loudest of all of the spirits that remain in the hospital, but to date he has not committed any acts of violence against the living.

The second legend concerns both the patient and the nurse that the man killed. There have been reports of a patient who walks aimlessly around the hallways as though in search of someone. Interestingly, the patient has never been seen in the hallway where the man who killed him resided.

The nurse has also been spotted frequently, still dressed in her uniform whites with her nurse's cap perched on her head. She appears to be trying to

stalk her killer for she mostly is seen around the man's room. She is a most imposing figure of stout build with a very intimidating personality. She can still be heard barking out orders, demanding that her patients pay attention to her and do exactly as she says or there would be the proverbial hell to pay. Most patients feared her, and she seems to have the same effect on any newcomers to the building who are not familiar with her.

If you live in the Nashville area and are in need of a job I can recommend one that you will have no trouble landing. And in addition to all of the regular benefits, you just might get a few that you didn't bargain for.

Enjoy your new job!

Please visit us at
www.historypress.net